IMAGES
of America

HOT RODDING IN VENTURA COUNTY

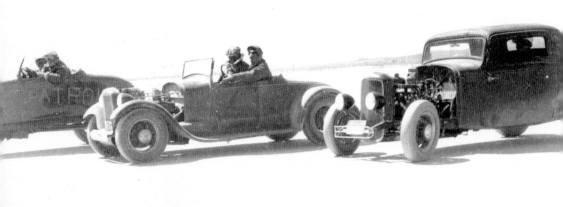

This evocative photograph shows Ventura residents Lee Ledbetter (at right in the center car) and Eddie Kulper (in car at right) at El Mirage Dry Lake in 1947. Ledbetter is driving the first car he built, a primer-gray, channeled 1929 Ford roadster powered by a four-banger. Jim Gray is in the passenger seat. Kulper is behind the wheel in his unfinished 1932 Ford coupe. Note the vintage racing attire the boys are wearing. The occupants of the car at left are SCTA officials that patrolled the lakebed for breakdowns and accidents. (Courtesy of Lee Ledbetter.)

ON THE COVER: The Kustomeers are pictured at Santa Maria Dragstrip in November 1957. (Courtesy of Jerry Williams.)

IMAGES
of America

HOT RODDING IN
VENTURA COUNTY

Tony Baker

ARCADIA
PUBLISHING

Copyright © 2013 by Tony Baker
ISBN 978-0-7385-9968-7

Published by Arcadia Publishing
Charleston, South Carolina

Printed in the United States of America

Library of Congress Control Number: 2012952317

For all general information, please contact Arcadia Publishing:
Telephone 843-853-2070
Fax 843-853-0044
E-mail sales@arcadiapublishing.com
For customer service and orders:
Toll-Free 1-888-313-2665

Visit us on the Internet at www.arcadiapublishing.com

Dedicated to Eddie Martinez and Dave Marquez

CONTENTS

Acknowledgments 6

Introduction 7

1. Starting Line: 1946–1949 9

2. Shifting Gears: 1950–1955 19

3. Top Eliminators: 1956–1963 41

4. People and Places 113

Glossary 126

ACKNOWLEDGMENTS

First of all, I would like to thank my good friend and colleague, Elnora Tayag, reference librarian and outreach coordinator at the John Spoor Broome Library at California State University, Channel Islands, for the inspiration, encouragement, and support that made this project possible. All of the images in this book, plus many others depicting the history of motor sports in Ventura County and in Central, and Southern California, will soon be available as part of a digital archive at the Broome Library. Thanks also to hot rod artist and writer John "Waldo" Glaspey, who gave me the idea, and to my friend and mentor, pioneer hot rodder Ambrose "Amby" Little.

Special thanks go to all of the car club members and their families who opened their homes and photo albums to me: C. Darryl Struth, Richard Martinez, Jim Harris, Lee Ledbetter, Jerry Williams, Bob Richardson, Ernie Cooper, Ernie Sawyer, Marv Houghton, Jim Bohlen, Wanda Nelson, George Rose, Dennis Williams, Mike Loftus, Ed Marks, Howard Clarkson, Bud Hammer, Nick Sweetland, Jack Taylor, Rodney Fernandez, Jim Monahan, and to anyone I may have accidently left out.

I would also like to thank Santa Paula, historian Craig Held, and the staff at the Santa Paula Library; Judy Weston, the reference librarian at the Oxnard Public Library; and my friend Charles Johnson, archivist at the Ventura County Museum of Art and History, along with the archive staff, for their patience and generous assistance.

Finally, thanks to my friends and neighbors Adam Randall and Tiffanie Wright of Squashed Grapes Winery in Ventura for the use of their office and computer, my old friend Harry Mishkin for his support, Ryan Rush for the many patient hours of technical assistance in putting this book together, my son Thomas, and my friends Byron Barnes and Dan Alvis.

In putting this pictorial history together, I've tried to present an accurate record of the contributions the hot rodders of Ventura County made to automotive culture. The captions were written from hours of recorded interviews with the people who were there. I hope you enjoy it.

INTRODUCTION

Motor sports have been a part of Ventura County since the early 20th century. As early as 1903, the local newspaper complained of "red devils" speeding through the streets of Ventura in their horseless carriages. Famous racecar driver Barney Oldfield raced an airplane on the beach at Ventura in 1915. Hill-climb races took place up the Dunshee Grade on the Rincon in the early 1920s. The first car club in Ventura, the Slug Slingers, was founded by Ambrose "Amby" Little and a group of Ventura High School students around 1937 and was sanctioned by the Southern California Timing Association in 1938. Around that time, El Mirage Dry Lake, four hours east of Ventura, became popular among car clubs throughout Southern California as the place to race. The dry lakebed's large flat surface and isolated location made it an ideal place to open up the throttle and see how fast a car could go. Members of the Slug Slingers were there during the early days, racing with such pioneers as Eddie Crager, Vic Edelbrock, and Bob Rufi.

World War II put a temporary end to the Southern California racing scene, as the young men of the car clubs went to fight for their country. Many who returned brought back with them mechanical skills acquired in the service. And there was a new generation of enthusiasts on the scene, raising things to a new level. Hot rodding was ready for a big comeback.

Ventura County in the late 1940s was a good place to start. It offered open roads, cheap fuel, and a large group of kids who, besides being car crazy, had the benefit of vocational training provided by California's excellent school system. Detroit was finally producing new cars, and this put a lot of cheap used cars, especially Ford Model As, on the market. There were also a lot of well-trained mechanics and machinists servicing the oil fields who spent their leisure time building cars. Then there was the intersection of Main Street and Ventura Avenue. This was the home to used-car lots, parts stores, upholstery shops, auto-body shops, and other automotive-related businesses. A few blocks west on Meta Street was the home of one of Ventura's first and best-known postwar car clubs, Motor Monarchs. North on Ventura Avenue lived members of an earlier club, the Whistlers, who would build a car that set a speed record at Bonneville.

As the 1940s turned into the 1950s, the car club scene in Ventura County continued to grow. The Motor Monarchs and the Whistlers were soon joined by clubs with names like the Kustomeers, the Gents, the Coachmen, and the Pharaohs. This was also when a new sport in California, drag racing, was beginning to take root. The objective was to compete with another car for the best time from a standing stop along a quarter-mile course, basically a long strip of pavement. The first drag meet was held at Goleta, and soon other "drag strips" were starting up in the area. The Motor Monarchs and the Whistlers, as well as many of the later clubs, were active and successful participants in this scene. The Monarchs were the dominant force.

Led by the Martinez brothers and operating from a small garage behind a tortilla factory, this club would become famous, appearing on the cover of *Hot Rod* magazine and many others during the era. The first club to approach drag racing in a professional manner, the Monarchs were also known for the superb appearance of their cars. They won countless races at famous early strips

like Santa Maria and Saugus, and would go on to successful runs at the first two National Drag Racing Championships, in Great Bend, Kansas, in 1955 and Kansas City, Missouri, in 1956.

One aspect of this period was that most of the car clubs in Ventura were considered "good guy" clubs, in that they tried to counter contemporary media depictions of hot rodders as juvenile delinquents. Local clubs engaged in community services, such as food drives and other acts of charity, and stressed courtesy and safety on the road. Their relations with law enforcement were generally good as well. Many clubs had one or two police officers as members, and a few clubs were informally sponsored by local police departments. Except for the occasional late-night street race, the clubs were a generally law-abiding group. Many car club members went on to become successful businessmen and prominent community leaders.

A rather ironic aspect was that, for all the contributions that Ventura hot rodders made to drag racing, no drag strips were actually located in the county. When the Motor Monarchs started, most of the drag racing in the Ventura area was done on Pierpont Boulevard or on the road to the old city dump. As things got more organized, the Monarchs, with other clubs, tried to get permission from the City of Ventura to hold races on the seldom-used road. Over a period of two and a half years, the club went through the legal channels required to get the permits and made an effort to gain public support. All that came to an end in 1954. One day, while cleaning up the area, several club members were burning weeds by the roadside. The smoke got heavy, and although the Monarchs blocked the road for safety, a citizen decided to proceed anyway. A minor traffic accident ensued, and even though no one was hurt, the damage was done. The following week, the Ventura city council canceled the permit process the Monarchs had started. Ventura would not have its own drag strip.

The middle and late 1950s was the peak time for the car club scene in Ventura County, with as many as 16 different clubs in operation. Cruise nights, or "running the drag" up and down Main Street and hanging out at Merle's Drive-In, were the order of the day. But by the end of the 1950s, however, things started to change. Most of the original group of hot rodders had grown up and moved on to start careers and families. The city of Ventura was expanding, and with development there were fewer long, empty country roads to race on.

Drag racing had changed, too. It was becoming a professional sport with big industry and media support. The Motor Monarchs and clubs like them, for all their success, were still amateur organizations, and the sport was becoming dominated by individual personalities like Don Garlits, Mickey Thompson, and Tommy Ivo. By 1963, drag racing had gone truly national when the NHRA championships were held at Indianapolis, Indiana, and televised by a major television network. Today, there are drag strips all over the country. But it all began out here. . . .

One

STARTING LINE
1946–1949

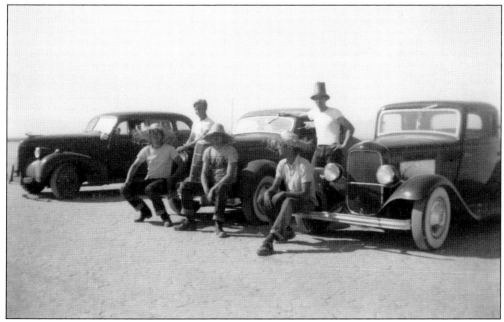

This group from Ventura takes in the scene under the desert sun at El Mirage Dry Lake in the late 1940s. Seated at right is hot rod builder Don Mansfield. The chopped 1932 Model B on the right, built by Mansfield, was soon sold to the Martinez family as a birthday present to Richard Martinez. (Courtesy of Richard Martinez.)

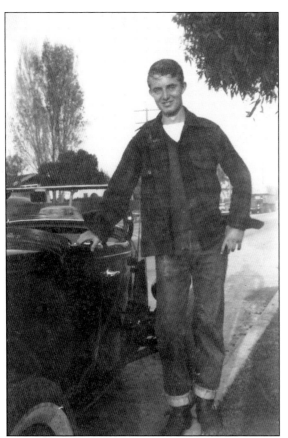

The first postwar club in Ventura was the Whistlers, founded in 1947 by returning war veteran and Ventura College student Ray Rude. The Whistlers were made up of young men in their early 20s and Ventura High School students. One of the earliest members was Michael Loftus, posing here with his 1932 Ford Model B highboy roadster. (Courtesy of Michael Loftus.)

This interesting photograph shows Michael Loftus standing by a friend's 1940 Ford convertible. This gas station was owned by the Buck brothers and located at the corner of Main Street and Pacific Avenue. Loftus's hot rod is seen in the background. Loftus had previously owned what was considered the fastest car in Ventura; a straight-eight-powered 1937 Hudson that was modified into a roadster using the rear end from a 1932 Chevrolet. (Courtesy of Michael Loftus.)

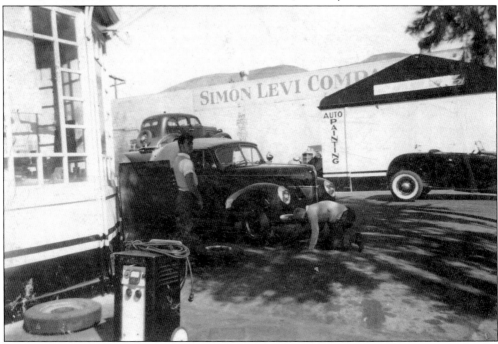

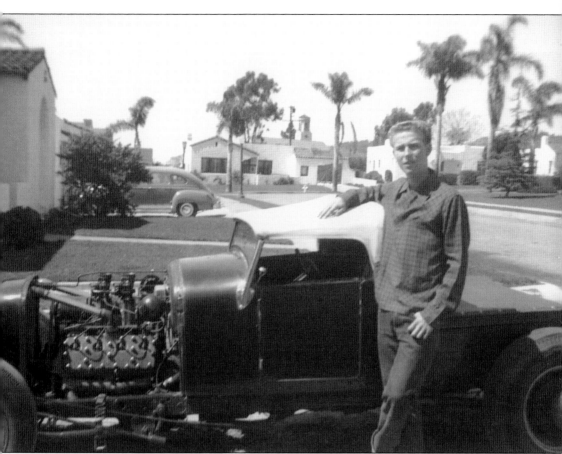

George Rose was another Ventura High student who joined the Whistlers. He would also become a member of the Satyrs car club. He is seen here with his 1927 Ford Model T roadster in front of his family's home on Santa Barbara Avenue in Ventura. The maroon T-bucket hot rod was built by local body and paint man Leroy Farar at his family's business in Ventura. Rose bought the rod in 1948 and drove it until it was destroyed by a drunk driver in an accident in the early 1950s. Rose replaced it with a chopped 32 Ford Tudor. A well-liked personality in the local scene, Rose was and still is well known for owning some of the best-looking and best-assembled cars in the county. (Courtesy of George Rose.)

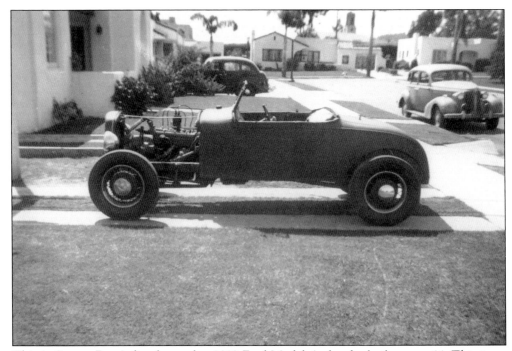

This is George Rose's first hot rod, a 1929 Ford Model A that he built at age 14. This is an excellent example of what a late-1940s hot rod looked like. These early cars were usually made from junkyard parts and assembled at home or in the Ventura High School automotive class under the instruction of shop teacher Arthur Cox and, later, his replacement, George Frasier. (Courtesy of George Rose.)

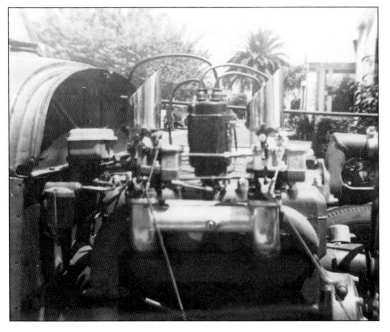

Here is the Ford four-cylinder engine, or "four-banger," that powered George Rose's first rod. It is typical of what was available to a teenager building a hot rod in the postwar era. Being of homemade construction, the bored and stroked engine has been equipped with dual Stromberg carburetors and chromed straight intake pipes. (Courtesy of George Rose.)

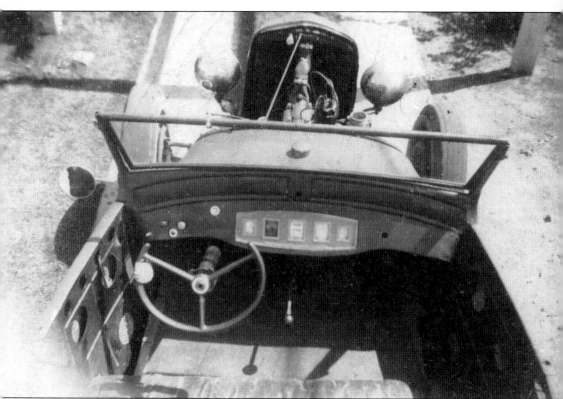

This image shows the cockpit of George Rose's Model A. Note how the upholstery has been stripped out of the interior and the Ford dashboard removed and replaced by one from another car. The steering wheel appears to have come from a World War II–era Boeing B-17 bomber and has a knob attached to it to assist in steering. (Courtesy of George Rose.)

Another early hot rodder and member of the Whistlers was Ed Marks. He worked for the local GM dealership in the parts department and was known for his encyclopedic knowledge of the General Motors parts catalog. Marks is shown here in 1946, seated behind the wheel of his 1932 Ford pickup at his home on East Meta Street. Visible in the left background is the top of Grant Memorial Park, which today is covered with trees. The flathead-powered deuce pickup is wearing a basic primer-gray paint job, common for most hot rods of the era. Note the smaller headlamps, most likely from a Chevrolet. Ed's friend Eddie Eubanks is standing to the left. (Courtesy of Edwin Marks.)

Ed Marks also built cars. Shown here is the 1932 Ford roadster that he built for fellow Whistler Bob Neville. Marks replaced the Ford headlamps with smaller Chevrolet units and placed them lower down for a cooler look. The car is equipped with wire wheels, as were most early cars. Steel wheels were not generally available until the late 1940s. The car is powered by a flathead engine with a single open carburetor. (Courtesy of Edwin Marks.)

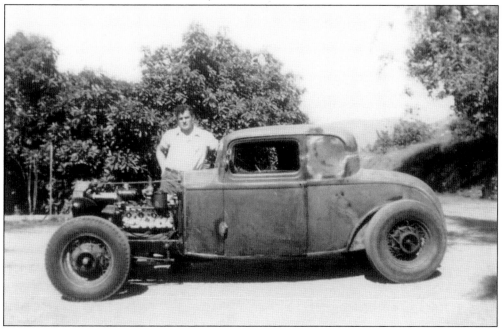

Whistler member Earl Pape stands behind his unfinished flathead-powered 1932 Ford five-window coupe. He has channeled the body, chopped about three inches off the top, and blanked out the quarter windows with steel plate. The headlamps and the radiator shell appear to have come from an early-1930s Packard. This car would compare well with many of today's rat rods. (Courtesy of Edwin Marks.)

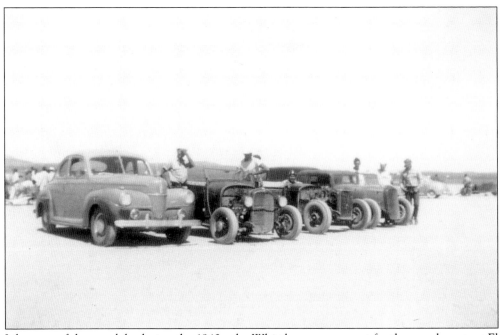

Like most of the car clubs during the 1940s, the Whistlers were present for the speed meets at El Mirage Dry Lake. This lineup of club members' cars looks ready to race. Shown here are, from left to right, a 1941 Ford coupe, Ed Mark's Deuce pickup, a stripped-down Model A roadster, and Earl Pape's 1932 Ford coupe. (Courtesy of Edwin Marks.)

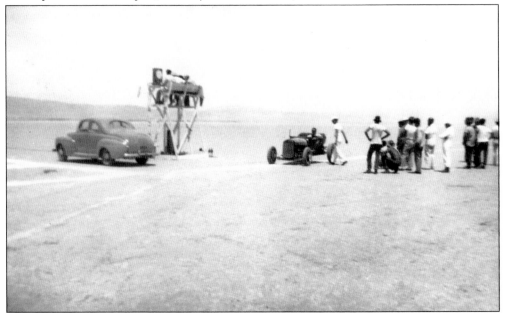

This is a rare photograph of the Southern California Timing Association tower at El Mirage. The racers were timed using the equipment just visible on the left side of the tower. It must have been uncomfortable for the timing officials to sit all day exposed to the desert sun. Left of the tower is the coupe belonging to Ed Mark's father, who was officiating that day. (Courtesy of Edwin Marks.)

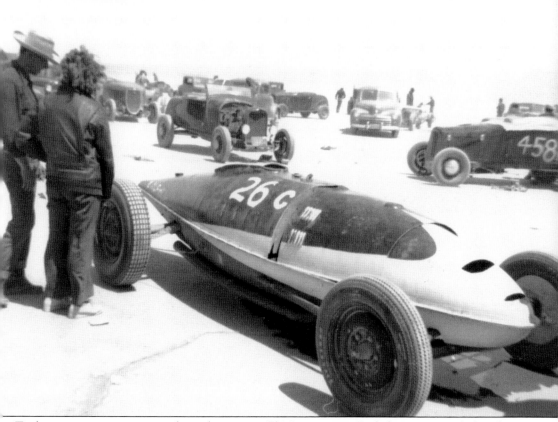

Tank racers were a common sight at the postwar El Mirage meets. Built from aviation fuel tanks bought as war surplus, their aerodynamic shape and light weight made them an excellent platform for constructing a lake racer. Tank racers were powered by everything from Ford four-bangers, to Chevrolet stove-bolt sixes, to built-up flatheads. (Courtesy of Edwin Marks.)

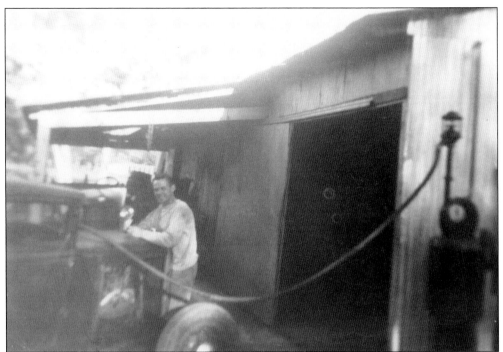

This 1947 photograph shows 22-year-old Ron Williams filling up his 1930 Ford at the school bus shed on Burnham Road in Oak Park, next door to his family's home. Ron's father drove the bus for the local school district. Back home after serving in the Navy during World War II, Ron was an early member of the Whistlers and built the coupe shown here for getting around Ventura. He has radically chopped the top and removed the fenders and running boards. The color appears to be black. It was powered by a dual port Riley-Ford four-cylinder engine. Companies like Riley and Miller made upgrade kits that would squeeze as much horsepower from a Ford four-banger as was possible. (Courtesy of Dennis Williams.)

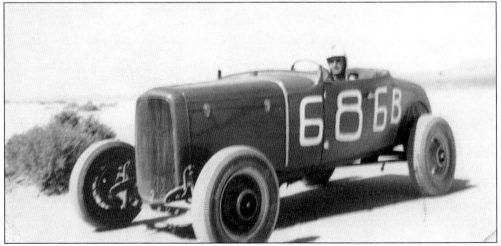

The coupe, re-bodied with a dark green roadster body, is shown here at El Mirage on August 29, 1948, when it attained a speed of 102.5 miles per hour. Ron Williams worked as a machinist at Chanslor & Lyon and would later go on to own his own successful machine shop. He continued to run the Riley-Ford until a piston froze one Halloween night in 1948. (Courtesy of Dennis Williams.)

Two

SHIFTING GEARS
1950–1955

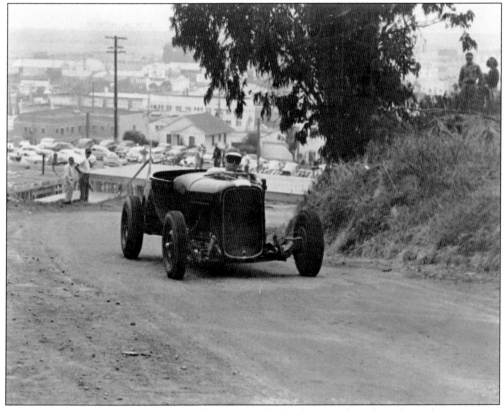

Ron Williams replaced the Riley with the maroon, flathead-powered roadster shown here storming up the road to the Padre Serra Cross at Grant Memorial Park in 1953. Ron responded to a challenge issued by the Tri-Counties MG Club that his Ford hot rod could not beat an MG in a hill-climb race. He wound up winning the event with a time of 52.554 seconds. Main Street is visible in the background. (Courtesy of Dennis Williams.)

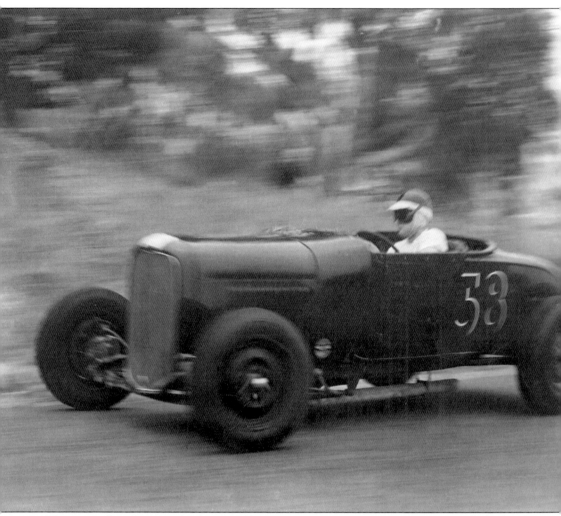

This is another photograph of Ron Williams racing up Brakey Road during the hill climb. This 1929 Ford Model A roadster was powered by a 1937-year, 244 cubic-inch, alcohol-burning flathead V-8 equipped with four Stromberg 97 carburetors. In this configuration, the car placed third in Class B at the 1951 El Mirage meet with a speed of 125.69 miles per hour. The flathead was replaced with one of the first Hemi engines in the area and was tuned by Ron's brother Herb, a specialist on carburetors and ignition systems. With the new engine, the car would go on to take the national record for Class B roadsters at Bonneville Salt Flats, Utah, with a top speed of 159.57 miles per hour in September 1954. Williams would go on to found Ron Williams Automotive Machine Shop, which is still operated by his son Dennis at its original location in Ventura at 1291 North Olive Street. (Courtesy of Dennis Williams.)

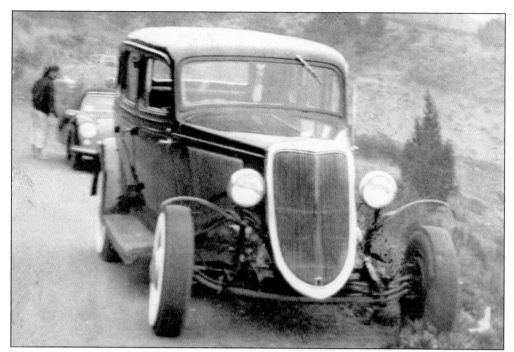

Also participating in the hill climb on Brakey Road on that day in 1953 was Jim Bohlen of the Gents car club, in his black 1934 Ford Fordor sedan. Jim has removed the front fenders for the race, although the brackets that held them up are still visible. Note the early Porsche speedster in the background. (Courtesy of Jim Bohlen.)

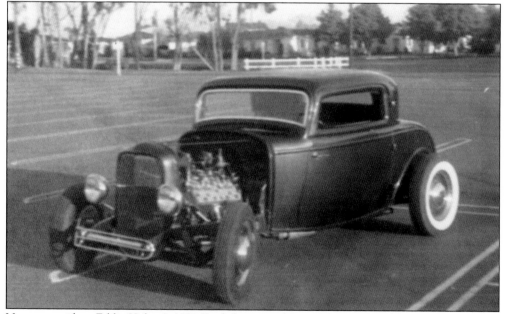

Ventura resident Eddie Kulper's 1932 Ford three-window coupe is pictured here at the Ventura High School parking lot in 1948. A heavily chromed flathead V-8 is in the engine compartment, and the body has been channeled and the top chopped three inches. A front nerf bar and metallic forest green paint job make for a very cool-looking hot rod. (Courtesy of Lee Ledbetter.)

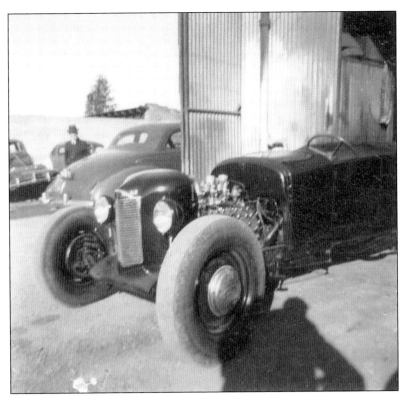

One of the best-looking hot rods in Ventura in the late 1940s was this 1927 Ford Model T roadster, built by Leroy Farrar at his family's body and paint shop located between Main Street and Santa Clara Street, off Palm Avenue. Farrar did a beautiful job of adapting an early-1940s Packard grill shell to fit the Ford's body styling. (Courtesy of Lee Ledbetter.)

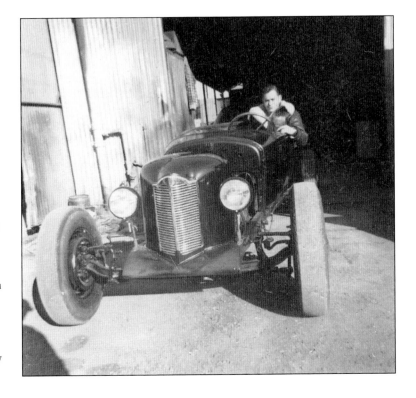

Lee Ledbetter, wearing a leather flight jacket, sits in the Model T at the entrance of the body and paint shop. Note how Leroy Farrar used late-1930s sprint-car styling on the grill shell. The headlamps are 1930 Chevrolet units. The Farrar family business was a fixture in downtown Ventura for over 30 years, operating out of this simple corrugated metal building. (Courtesy of Lee Ledbetter.)

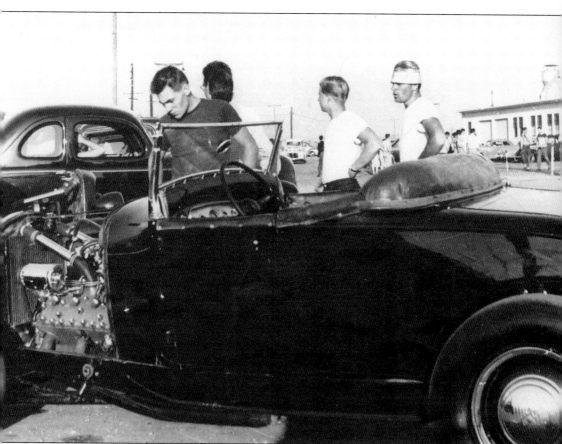

Lee Ledbetter (far right) prepares his 1929 Model A roadster for a day of racing in Goleta, California, in early 1951. The black highboy was powered by a bored and stroked flathead equipped with a tri-carb setup and a lot of chrome accessories. The upholstery appears to be either oxblood or brown. Next to Ledbetter is John McFadden of Ventura, checking out the 1940 Ford coupe in the background. At left is a sailor/hot rodder (whose actual name is lost to time) stationed at Point Mugu Naval Air Station who was nicknamed "Barney Oldfield," after the famous race car driver. Race meets at Goleta started out as informal affairs. A livestock crossing marking the end of the strip became the finish line. This turned out to be exactly a quarter of a mile from the starting line. That distance became the standard length for all drag races. (Courtesy of Lee Ledbetter.)

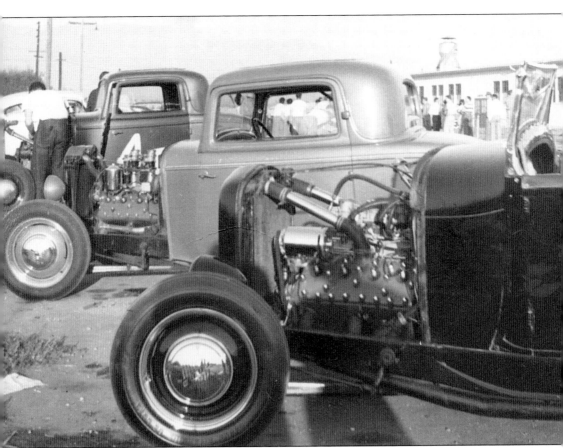

Hot rods are seen lined up at the Goleta drags, reputed to have been the first drag strip in the country. Some sources state that racing began there in January 1951. Clubs from Santa Barbara and Ventura began meeting there to race shortly after the former Marine air station closed at the end of World War II. Drag racing at Goleta lasted only about a year; the strip was replaced by operations at Saugus, Bakersfield, and Santa Maria. In the background can be seen the flight-line administration buildings and the base water tank. In the foreground is Lee Ledbetter's black 1929 highboy. Behind it is John McFadden's metallic blue three-window coupe. Nothing is known about the rod in the back, but it is a cool-looking car. (Courtesy of Lee Ledbetter.)

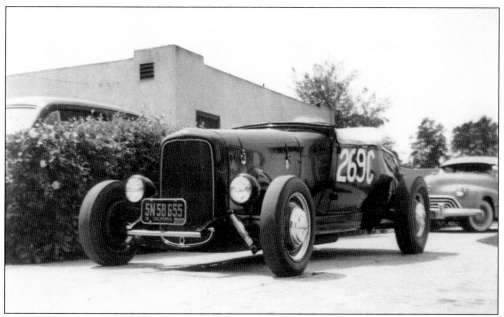

Lee Ledbetter's 1929 Ford highboy is seen here at his family's home on Santa Rosa Avenue in Ventura. It has been buttoned-up for a trip to El Mirage Dry Lake. Speed runs at El Mirage took place for only a few years after the war before moving to Bonneville Salt Flats, Utah. (Courtesy of Lee Ledbetter.)

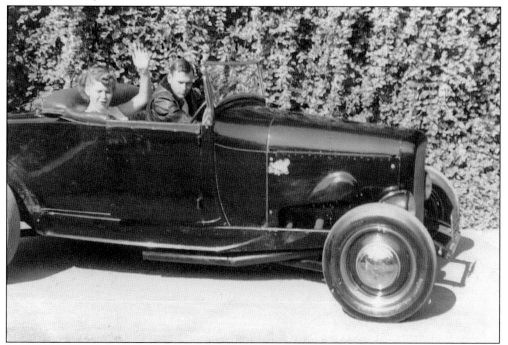

Lee Ledbetter is seen here with a girlfriend in his highboy. This photograph was taken at the Kimball Ranch, which was located beyond the outskirts of Ventura on Telegraph Road. It was a popular place for local hot rodders to hang out and was also the headquarters of the Whistlers. (Courtesy of Lee Ledbetter.)

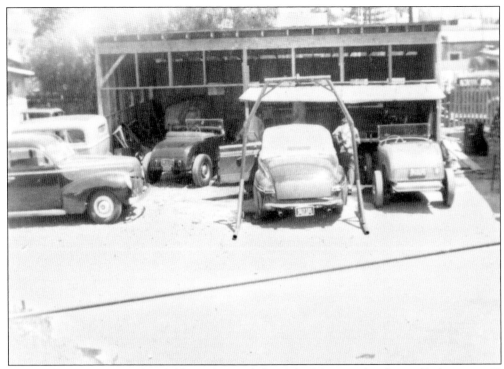

This is the Motor Monarchs' clubhouse/garage behind the Martinez family tortilla factory at 33 Meta Street, now Thompson Avenue, in old town Ventura. The clubhouse was built by the father of Eddie and Richard Martinez as a way to keep his mechanically talented sons busy and out of trouble. This photograph is from around 1950. (Courtesy of Lee Ledbetter.)

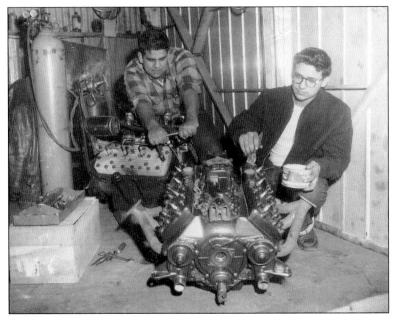

Brothers Eddie (left) and Richard Martinez work on a Mercury flathead in the garage, sometime around 1950. The brothers, natural mechanics, would become key figures in the growing car club scene. Older brother Eddie would become the Motor Monarchs' first president.

The Martinez garage became a hangout for local hot rodders and many others from all over Southern California. Seen here relaxing and enjoying a cold beverage are, from left to right, an unidentified man, Harvey Eggman (Gophers car club of Pasadena, California), local hot rod builder Don Mansfield, and Eddie Martinez. (Courtesy of Richard Martinez.)

The group that hung out the most in the brothers' garage eventually became the Motor Monarchs car club, founded in 1950. Shown here are, from left to right, Richard Martinez, Norman Ward (smoking cigar), Dave Marquez (in back), Ben Martinez, Larry Dransfeldt, Howard Clarkson, two unidentified, Eddie Martinez (leaning over car), Jack Cantrell, and unidentified. The car in the photograph is the unfinished club project car, the "440 jr." (Courtesy of Richard Martinez.)

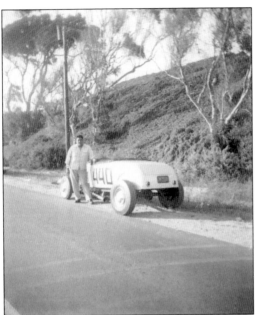

Around 1950, the Motor Monarchs built their first car, a chartreuse green 1929 Ford Model A highboy roadster that carried the race number 440. It was one of a small number of stripped-down rods made especially for drag racing in California at that time. Eddie and Richard Martinez built the car, and for a time it was powered by a blown Cadillac engine of Eddie's. (Courtesy of Richard Martinez.)

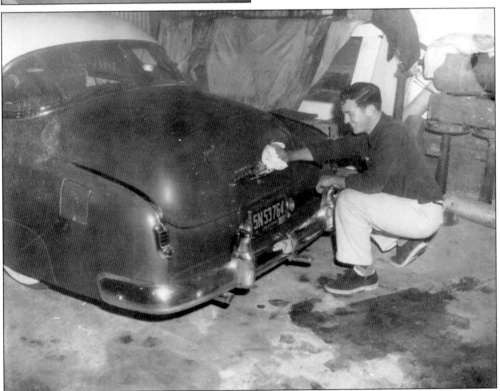

Motor Monarch Howard Clarkson polishes his new 1951 Chevrolet. Clarkson would become Class A Top Eliminator at the second NHRA National Drag Races in 1956, owning and driving the club project car, the No. 550 "Cyrano." He also became club president. The Chevrolet would be heavily customized and was featured in the March 1958 issue of *Custom Car* magazine. (Courtesy of Richard Martinez.)

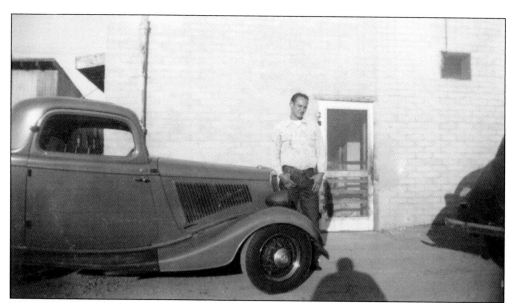

Motor Monarch Robert Olinger stands behind the Martinez tortilla factory with his 1934 Ford coupe. When he was a child, Olinger lost his hearing in an oil-field accident. Using signing to communicate, he managed to lead a normal life and was a well-liked member of the club. (Courtesy of Richard Martinez.)

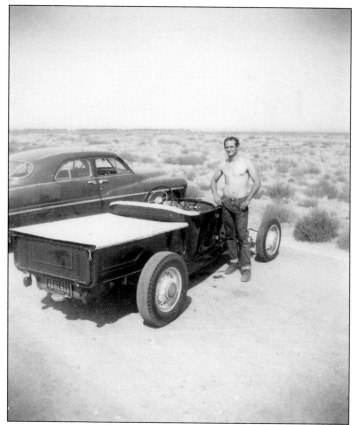

Robert Olinger stands next to his 1923 Model T pickup at Bakersfield. In 1953, while at the Ventura County Fair with the Monarchs, he attended a Bell-Tone hearing-aid demonstration and was stunned at the effect when he tried one out. His fellow club members pitched in and raised $500 on the spot to buy Olinger a new hearing-aid. (Courtesy of Richard Martinez.)

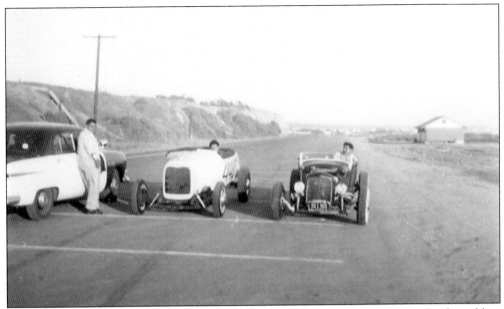

This image shows the 440 car being tested in the beach parking lot on Pierpont Boulevard late one afternoon in the early 1950s. Eddie Martinez is seen chatting with club member Jack Cantrell, who is seated in the police car. Cantrell was also a member of the Ventura Police Department. The red T-bucket (right) belonged to Ventura local Leo Jaramillo. (Courtesy of Richard Martinez.)

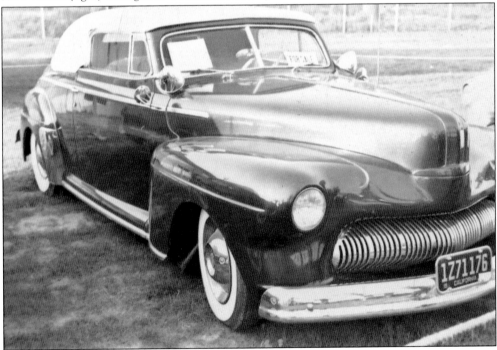

Shown here is Eddie Martinez's big, bad, and beautiful 1947 Mercury convertible. Eddie and Richard did the front-end treatment and finished the body with 20 coats of "blood red" lacquer. The car is wearing a Carson top. Like many of the brothers' cars, it had a few different engines, most notably, Eddie's bored and stroked flathead. (Courtesy of Richard Martinez.)

This photograph of Eddie Martinez's Mercury was taken in 1951, before it was completely customized. The windshield frame had already been chopped four inches, and a Carson top had been installed. The car is still in otherwise stock condition. When the customizing was finished, around 1953, most of the chrome had been removed and the headlights frenched. The grill was from a 1949 Mercury. (Courtesy of Richard Martinez.)

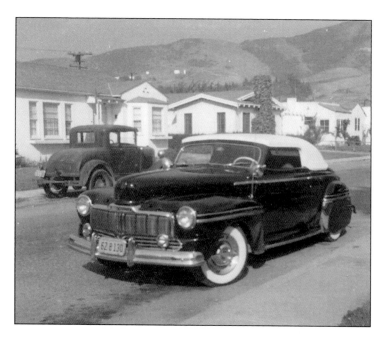

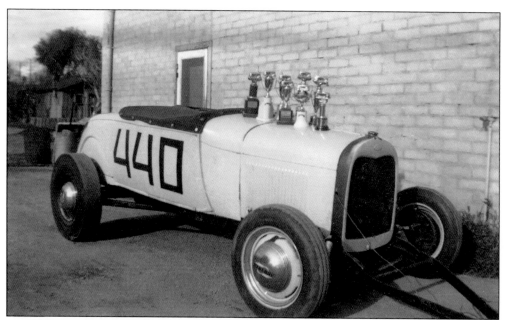

This is the Motor Monarchs' No. 440 roadster, pictured early in its career. On the hood are first-place trophies from its first eight races. The building is the Martinez tortilla factory, and around the corner but not visible is the Monarchs' clubhouse. The shed in the left background served as temporary housing for the Martinez family during the start-up of the family-owned La Mixteca tortilla factory in 1947. (Courtesy of Richard Martinez.)

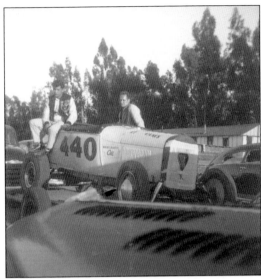

Ben Martinez (left), no relation to Richard and Eddie Martinez, is seated on the No. 440. He was frequently chief of the Motor Monarchs' pit crew in the early 1950s. He and Robert Olinger are both wearing their club jackets. Note that the opening for the radiator has been blanked out with cardboard and tape. (Courtesy of Richard Martinez.)

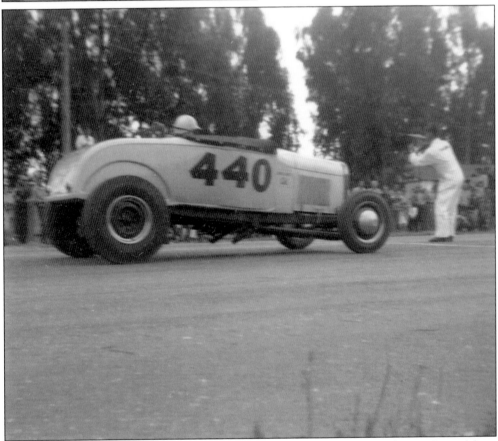

The No. 440 is seen in this dramatic photograph, poised on the starting line at Santa Maria drag strip in 1952. The camera has caught the flagman, visible at right, just as he is ready to drop the starting flag. On this run, the chartreuse-green dragster achieved 112.69 miles per hour on a quarter-mile and won Top Eliminator. (Courtesy of Richard Martinez.)

The 440 is on display at the 1953 Ventura County Fair. The Monarchs, along with other locals, were given permission to show their cars. To the left, a flathead engine built by the Martinez brothers is mounted on a display stand. (Courtesy of Richard Martinez.)

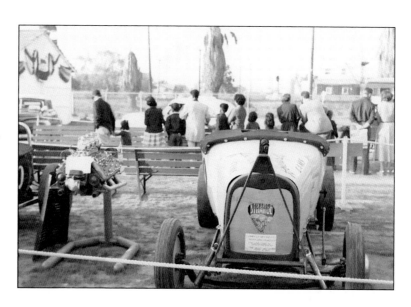

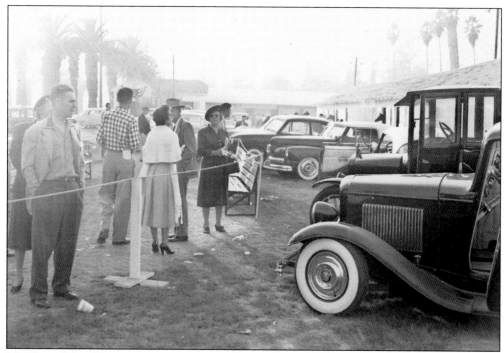

Members of the Ventura community attend what must have been one of the earliest hot rod shows in the county. The Motor Monarchs organized the display, as well as benefit dances and other acts of charity, as part of an effort to improve relations with the public. In the foreground of this photograph looking toward Ventura Avenue is the front end of Richard Martinez's 1932 coupe. Behind it is a restored "phone booth" Ford Model T, owned by Ventura Avenue hot dog stand owner Cal Gresset. Next, just visible behind the Model T, is the roof and open door of Howard Clarkson's Chevy. Beyond that is the Martinez brothers' 1947 Mercury and Richard Martinez's custom Ford coupe. (Courtesy of Richard Martinez.)

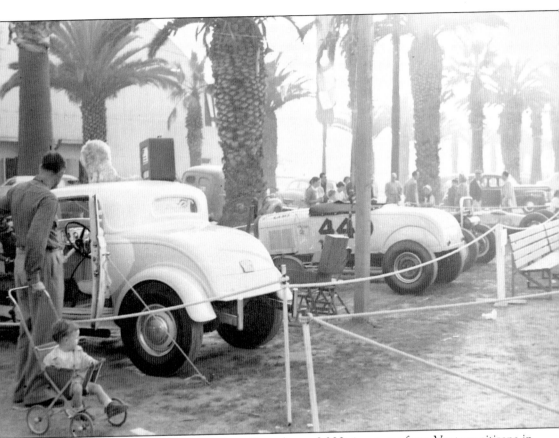

During the fair, the Motor Monarchs collected over 3,000 signatures from Ventura citizens in support of their efforts to build a drag strip in the city. This photograph, which is looking in the other direction from the previous photograph, includes one of the few known images of Dave Marquez's 1932 Ford coupe. The car, at left, is painted in the Day-Glo orange-and-white scheme that would become the club trademark. Note the stuffed lion mascot on the roof of Marquez's car. Next is the 440, and just visible behind that is the back end of Leo Jaramillo's T roadster. Jaramillo was a member of the Diablos car club of Ventura. The exhibit building on the left, still serving fairgoers today, is one of many left over from the fairground's days as a coastal artillery battery during World War II, when it was known as Camp Seaside. (Courtesy of Richard Martinez.)

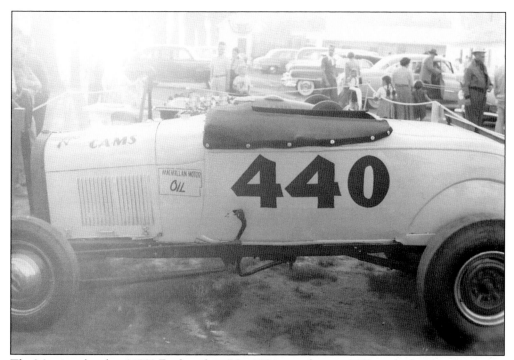

The Martinez brothers' 1929 Ford roadster No. 440 is seen here in 1953, at the height of its racing career. The really fine fit and finish of the racer is evident in this photograph. By this time, the car was successful enough to start picking up product endorsements. The tonneau cover was installed by Mac's Upholstery. (Courtesy of Richard Martinez.)

Richard Martinez attends the 1954 Los Angeles Car Show with his 1932 Ford Model B "deuce" coupe, built by Don Mansfield. Hot rodders from Ventura County made frequent appearances at car shows down south. Richard had the car painted a deep metallic red-purple, called "cherry-orchid," and had white Naugahyde upholstery installed. (Courtesy of Richard Martinez.)

Here is another photograph of Martinez's coupe, this time shown parked behind the tortilla factory. The full-fendered deuce coupe looks like it was chopped about two inches. Don Mansfield and Richard Martinez added smaller headlamps, 1950 Pontiac taillights, whitewall tires, Cadillac hubcaps, and a lot of chrome plating inside and out. (Courtesy of Richard Martinez.)

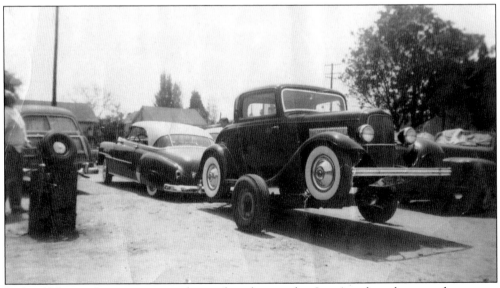

Richard Martinez's car is on its trailer, ready to be towed to Los Angeles, where car shows were usually held at the Pan-Pacific Auditorium. Howard Clarkson's Chevy is being used as tow car. The coupe, powered by a flathead engine, had a Mercury column shift that was installed by Eddie Martinez. (Courtesy of Richard Martinez.)

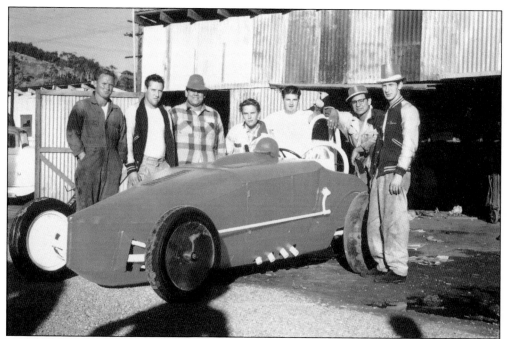

This 1954 photograph, taken by Norman Ward, shows members of the Motor Monarchs with the just-completed club project car, known as the No. 440 jr., and later to become the No. 550 "Cyrano." Shown here are, from left to right, John Davison, William "Zabo" Zavolosieck, Eddie Martinez, unidentified, Don Hardy, Richard Martinez, and Dave Marquez. (Courtesy of Norman Ward.)

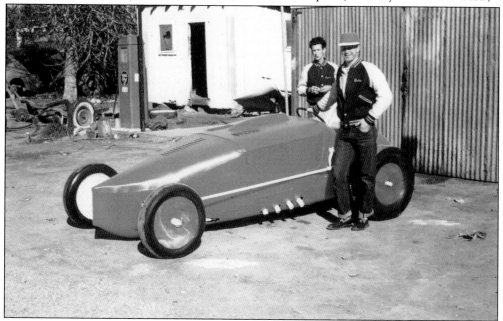

Posing with the club car are Dave Marquez (left) and Norman Ward. Motor Monarch Howard Clarkson would purchase the dragster from the club and add a long nose cone to the front, and the dragster acquired the nickname "Cyrano." In the background is a not-quite-legal gasoline pump that the club had installed next to the clubhouse. (Courtesy of Norman Ward.)

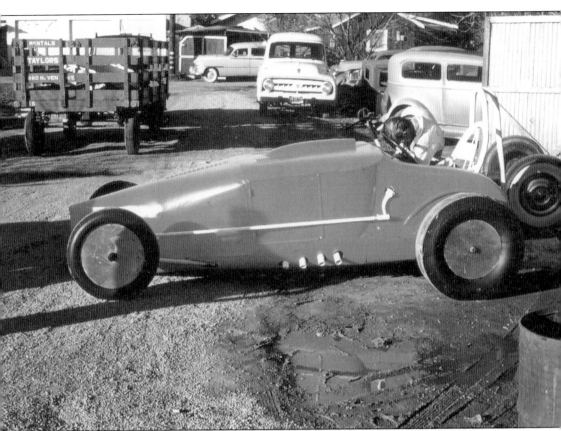

The club project car as originally built is seen here in profile. This must have been one of the earliest scratch-built dragsters ever constructed, although the first "rail" type drag racers began appearing in 1951. Note how the Model T body has been faired over and the driver's position relocated to above the differential. The steering arm has been lengthened and moved outside the body. The body forward of the firewall is hand-formed sheet aluminum, and note how the wheels have been covered to improve streamlining. The car is painted US Navy surplus Day-Glo orange, acquired from the nearby missile test center at Point Mugu. Behind the car, at left, is a trailer from Taylor Equipment Rental, 990 North Ventura Avenue, Casitas Springs. At center is the Marquez Bakery delivery van, and at right is a metallic pink 1932 Ford Tudor. (Courtesy of Norman Ward.)

The Motor Monarchs' project car, which raced as the No. 440 jr. and later as the No. 550, was known at all the drag strips on the central coast. Here, it is being readied to run at Santa Maria drag strip in 1953. Shown here are, from left to right, Howard Clarkson, Ben Martinez, unidentified, Eddie Martinez, and unidentified. Eddie Martinez's black Ford F100 is in the background at right, serving as push car. (Courtesy of Lee Ledbetter.)

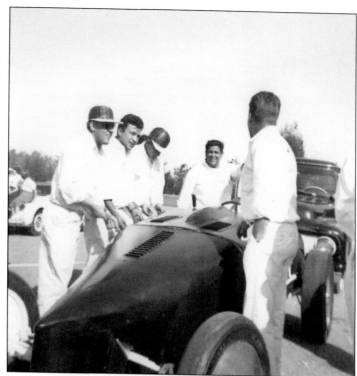

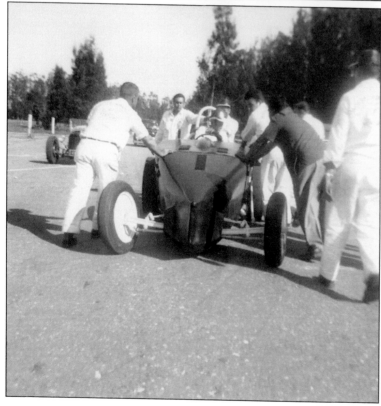

The No. 440 jr. is being pushed into position to race. Note the metalwork on the dragster's body. The Eucalyptus trees in the background identify this location as the Santa Maria drag strip, now just a memory. (Courtesy of Lee Ledbetter.)

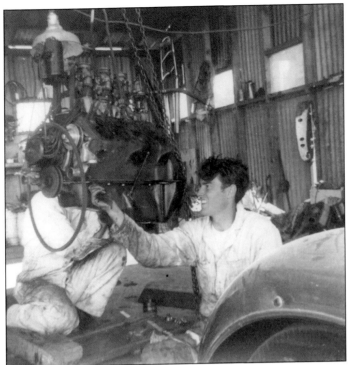

The Motor Monarchs' garage and clubhouse, in the alley behind Meta Street, was basic but adequate. Wearing greasy overalls is Willie Scurlock, seen here removing the oil pan bolts from a Ford flathead equipped with three Stromberg carburetors. Note the various spare parts and tools against the garage's corrugated metal walls. (Courtesy of Lee Ledbetter.)

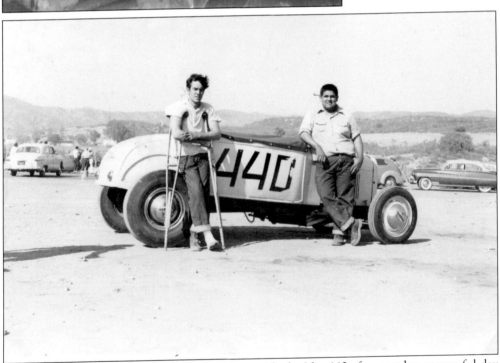

Willie Scurlock (left) and Eddie Martinez pose with the No. 440 after another successful day racing at Saugus in 1953. Scurlock and Martinez were two of the main drivers for the Monarchs at this time, along with Dave Martinez. Scurlock won Top Eliminator that day, in spite of a broken leg. Note the Pontiac taillights on the No. 440. (Courtesy of Lee Ledbetter.)

Three

TOP ELIMINATORS
1956–1963

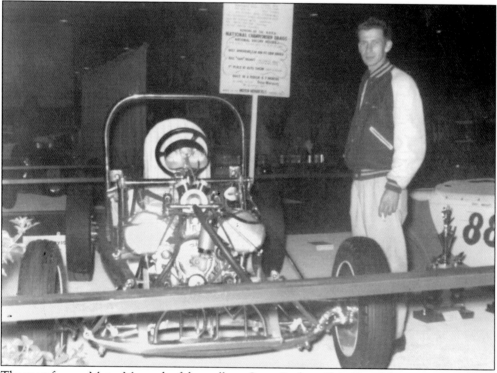

The most famous Motor Monarch of them all was Santa Paula resident Dave Marquez, pictured here with his award-winning roadster, No. 880, which had the now politically incorrect nickname "The Speedball Spic." The setting is the 1956 Motorama car show, held at the Pan-Pacific Auditorium in Los Angeles, California. Marquez drove the Ardun-powered 1932 Ford roadster to victory in the 1955 and 1956 National Hot Rod Association Championship drag races. In those years, he was Top Eliminator for Class B roadsters and won the Best Appearing Car and Crew award. Highly competitive, Marquez always strived to be the best at what he did. After a successful career as a drag racer in the 1950s, he became prominent in the world of off-road racing in the following decade, driving Baja Bugs in the Mint and Baja 1000 races for many years. A recipient of the Ventura Sportsman of the Year award, Marquez was also a successful businessman, owning the Marquez Bakery, a restaurant and bakery that was a Santa Paula fixture for many years. (Courtesy of Bob Richardson.)

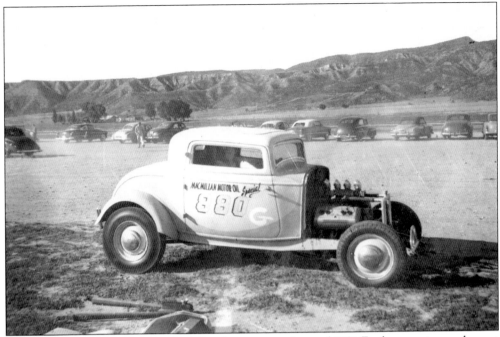

Dave Marquez's rarely photographed first drag racer, a chopped 1932 Ford coupe, is seen here at Saugus in early 1953. This racer was the first to carry Marquez's race number, 880, and also the first to wear the distinctive orange-and-white paint scheme that would be applied to all Motor Monarch dragsters. It was powered by the Ardun-Mercury V-8 that would later be installed in Marquez's famous roadster, the Speedball Spic. (Courtesy of Bob Richardson.)

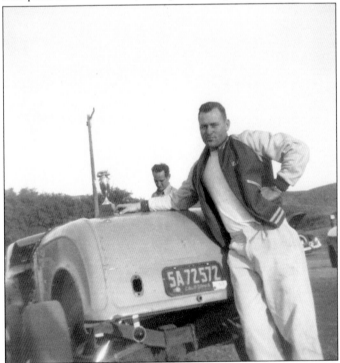

Lee Ledbetter, home on leave from his service with the Marines in Korea, poses after a successful day of racing at Saugus racetrack. He is wearing the early version of the Motor Monarchs' club jacket. The colors at that time were dark blue with buff sleeves and trim. Dave Marquez is in the background. (Courtesy of Lee Ledbetter.)

The first Motor Monarchs jacket logo featured a racing engine flanked by two lions holding a crown, with the words "Motor Monarchs" under the logo. The short "football" jackets would be replaced with the longer "car coats" that became popular in the later 1950s. Shown here are, from left to right, Howard Clarkson, Lee Ledbetter, unidentified, and Dave Marquez. In the right background is Clarkson's 1949 Chevrolet. (Courtesy of Lee Ledbetter.)

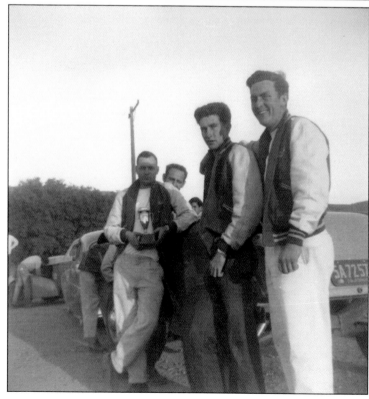

The Motor Monarchs pose at Saugus racetrack in 1953. The white pants and shirt with club jacket became standard attire for the Motor Monarchs at drag races throughout the 1950s. The car may be Dave Marquez's unfinished No. 880 Speedball Spic. Shown here are, from left to right, Lee Ledbetter, Dave Marquez, Eddie Holley, and Howard Clarkson. (Courtesy of Lee Ledbetter.)

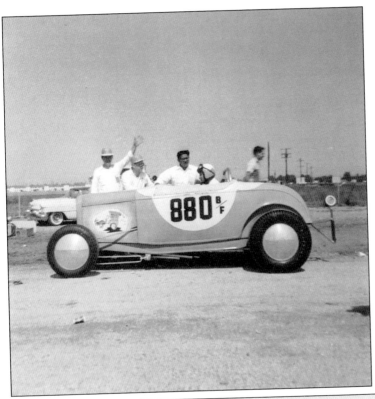

The Monarchs are racing Dave Marquez's No. 880 at Long Beach Drag Strip in 1956. Note the full Moon hubcaps on Dave's car. Shown here are, from left to right, Robert Olinger, unidentified, Richard Martinez, and Dave Marquez in the cockpit. (Courtesy of Lee Ledbetter.)

Crew chief Ben Martinez (left) and Dave Marquez service the No. 880 before the race. Drag racers like this one were called "fuelers," because they ran on exotic fuel mixtures instead of plain gasoline. Just visible between the men is Richard Martinez. (Courtesy of Lee Ledbetter.)

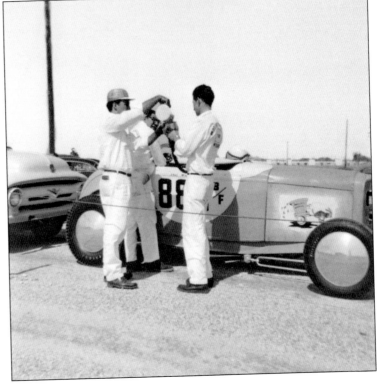

The No. 880, with Dave Marquez behind the wheel, is being pushed from the pit area to the starting line at Long Beach. Visible in the background are Richard Martinez (left), Eddie Martinez (center), and Ben Martinez. Note how Dave Marquez's initials have been worked into the chrome nerf bar. Like most drag racers, Marquez proudly displayed product endorsements for companies like Moon. (Courtesy of Lee Ledbetter.)

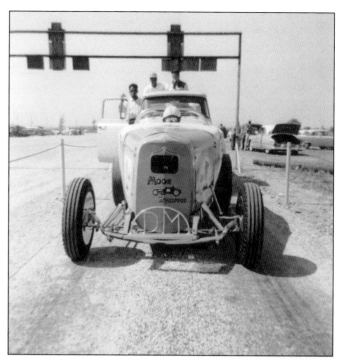

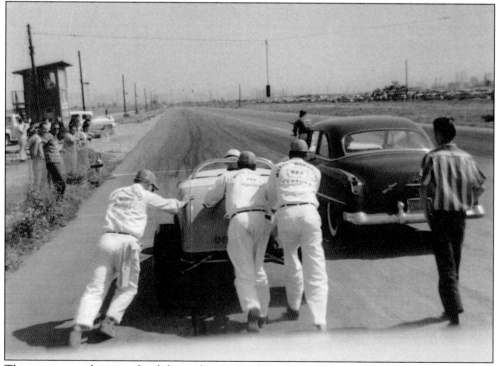

This is a great photograph of the early starting line at Long Beach Drag Strip. Note the old timing tower at left and the red-yellow-green starting lights hanging from the wire at center. Dave Marquez appears to be racing an Oldsmobile 88, so it may have been a "run what ya brung" race day at the strip. (Courtesy of Lee Ledbetter.)

Among the many cars owned and driven by Dave Marquez was a sweet little red 1927 Ford Model T built on a 1932 frame. Bob Lindsay rebuilt this flathead engine that powered it, adding Weiand heads and a Kong ignition system. It was equipped with three Stromberg 97 carburetors and featured an exhaust cut-off, to increase power when racing. (Courtesy of Bob Richardson.)

The front grill shell on Dave Marquez's T-bucket came from a 1932 Ford. The bias-ply tires on the front probably made for skittish handling in wet conditions. Like most of the cars that Marquez owned, this car was featured in an issue of *Hot Rod* magazine. It is seen here at the Texaco station run by Motor Monarchs member Bob Felkins. (Courtesy of Bob Richardson.)

Dave Marquez bought his T-bucket from a car lot in Van Nuys, California, that specialized in hot rods and customs. He paid $1,500 for the car, which was a lot of money in those days. This view of the well-appointed, fire-engine red hot rod shows why. Note how the rod's body has been channeled. (Courtesy of Ernie Cooper.)

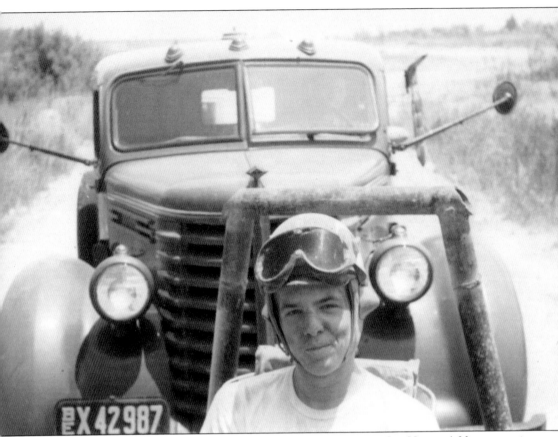

One of the most influential figures in the Ventura racing scene was Jim Harris. A Ventura native, Harris's father was the owner of Harris Motors, a Desoto dealership on Thompson Avenue. Jim Harris is seen here at age 14 behind the wheel of his first rod, a cast-off T-bucket that he rebuilt himself. A born mechanic and natural engineer, Jim started off as a yard boy at his father's car dealership, preparing used cars for resale. He recycled discarded parts onto his own hot rod. A graduate of Ventura high school, he was a prominent member of the Kustomeers and later the Motor Monarchs, and towed his rod to the 1956 championships with the Monarchs team. Harris, a well-known and respected member of the Ventura hot rodding community, went on to become a designer of industrial water purification systems as CEO of one of the largest companies in the West. (Courtesy of Jim Harris.)

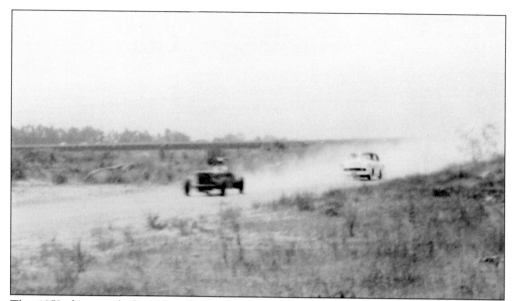

This 1952 photograph shows Jim Harris (left) racing a friend's Chevrolet on the dirt roads of a gravel quarry near the Santa Clara River in Saticoy. The car was a Model T roadster on a deuce frame powered by a worn-out flathead. Harris milled the heads and fashioned a crude roll bar out of oil-field pipe. (Courtesy of Jim Harris.)

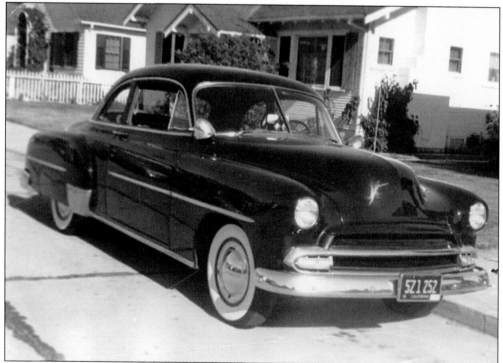

This black 1951 Chevrolet is an excellent example of early-1950s custom bodywork. The hood has been nosed and the headlights frenched. The front grill treatment is simple but cool. The body has been slightly lowered and is wearing fender skirts. Wide whitewall tires and fake spotlights on either side of the hood complete the package. (Courtesy of Lee Ledbetter.)

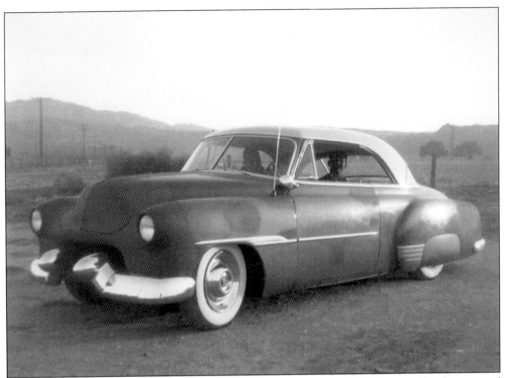

Howard Clarkson drove this custom 1951 Chevrolet Deluxe coupe. The front end has been nosed and frenched. The body has been lowered and the rear end decked. For trim, Howard has added fender skirts, whip antennae, fake spotlights, wide whitewall tires, Cadillac hubcaps, and Cadillac front chrome bumpers. The colors were primer gray and light blue. (Courtesy of Lee Ledbetter.)

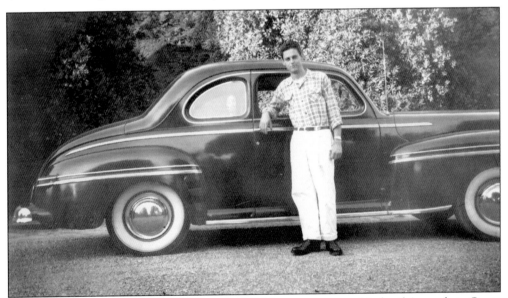

Ernie Cooper stands with his mild custom 1947 Mercury coupe at his family's ranch in Santa Paula in 1951. He was a pit-crew member for Dave Marquez and the Motor Monarchs throughout the early 1950s, until he was drafted into military service. (Courtesy of Ernie Cooper.)

Ernie Cooper's midnight blue Mercury is a good example of late-1940s and early-1950s mild custom styling. The hood has been nosed, and the whole area below the grill has been filled in with lead. It still has the stock grill, but the headlight rims have been replaced with Desoto units. (Courtesy of Ernie Cooper.)

Ronny Cox of Santa Paula is seen here with his black 1940 Ford coupe, one of many sharp-looking cars that he owned at different times. Cox was famous locally for having been caught racing his T-bucket hot rod through the storm drains and irrigation canals of east Ventura County. (Courtesy of Ernie Cooper.)

This photograph, taken in the early 1950s at the Richardson ranch in Santa Paula, shows how hot rods were put together at that time. More often than not, they were assembled from junkyard wrecks using the most basic of tools, and the work was done in a driveway, garage, or barnyard. The chopped deuce coupe body seen here will be lifted using old-school block and tackle attached to a peppertree, and the frame will be rolled underneath. It is sitting on the bare earth without benefit of hydraulic jacks or rotisserie gear. Someone has already added Chevrolet taillight lenses. The words on the coupe's trunk lid read "Cam Cracker." Note the old-fashioned water tank at left. (Courtesy of Bob Richardson.)

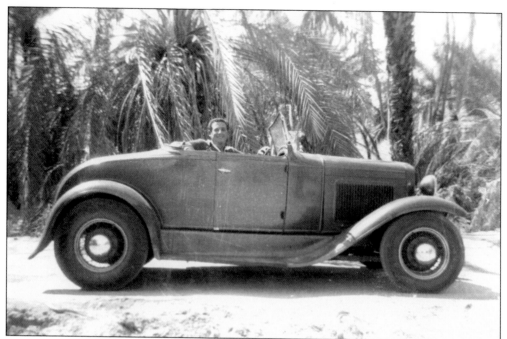

Bob Richardson of the Silent Knights was a prodigious hot rod builder, completing nine in less than five years. He is seen here behind the wheel of a flathead-powered 1930 Ford roadster. The car's body is still pretty stock, sitting high on its frame and retaining all four fenders. It belonged to a member of the Throttle Stompers of Thermal, California. (Courtesy of Bob Richardson.)

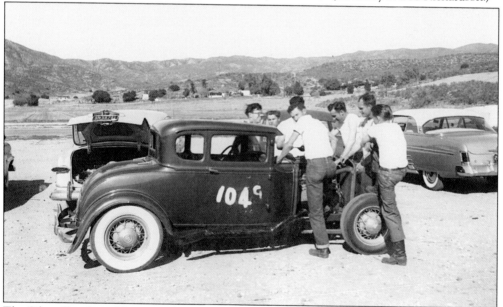

The Silent Knights of Santa Paula were founded in 1952 by former members of the Santa Paula Roadsters, a prewar car club, and students at Santa Paula High School. The Knights are seen here at Saugus drag strip in early 1953 with member Ed Low's 1932 Ford coupe. Shown here are, from left to right, Edward Low, Donald Shaw, Bob Lindsay (partially obscured), Dale Condren, Dick Blankenship, Bill Everett, and Max Couch. (Courtesy of Bob Richardson.)

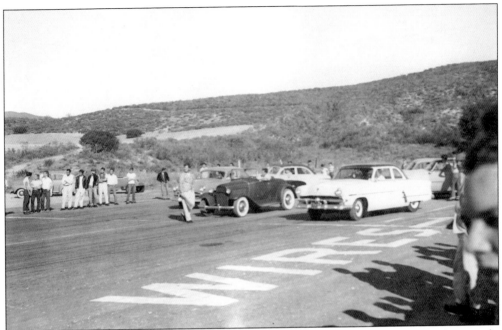

Saugus drag strip was, like all the early drag strips, a former airfield runway. In this photograph, the flagman is walking to the center of the strip in order to start the race. A 1932 Ford roadster is going up against a brand-new Ford coupe, so this must have been an open competition day at the strip, also known as "run what you brung" races. (Courtesy of Bob Richardson.)

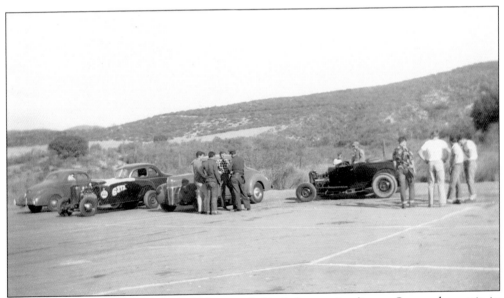

This is an interesting photograph of the area behind the starting line at Saugus drag strip in 1954. Second from left is a flathead-powered Ford highboy dragster in front of a couple of early-1940s coupes. Behind the center group is a 1940 Ford coupe that has had the headlights blanked out. At right is another highboy, this one powered by a large overhead V-8, possibly a Cadillac. (Courtesy of Bob Richardson.)

This photograph of the Saugus staging area shows the thick chaparral surrounding the strip. Among the cars seen here in the left foreground is a 1936 Ford Deluxe coupe that has had the rear end completely decked and the taillights moved atop the 1946 bumper. It sports wide whitewall tires and possibly Pontiac hubcaps. Also shown here are Bob Lindsay's coupe in the center foreground and Ed Low's 1930 Model A, right center. (Courtesy of Bob Richardson.)

The big oak tree shown here served as the concession stand for the Saugus drag strip in the early 1950s. In contrast to today's huge, purpose-built facilities with air-conditioned snack bars, food service in that earlier era consisted of a few picnic tables and coolers under a tree. This well-to-do racing crew is standing around their custom-made dragster (at center), which has been towed to the meet by a new Cadillac convertible, at right. (Courtesy of Bob Richardson.)

This rough but fast-looking 1934 Ford Fordor from Santa Paula is parked in the Saugus staging area. Behind it, a member of the Kerb Krushers car club, from West Los Angeles, and a friend are examining an early go-kart. Just visible in the left background is the front end of Lou Baney's hot Model A lake racer. Baney was the Saugus drag strip co-owner. (Courtesy of Bob Richardson.)

Well-known hot rod personality Jack Chrisman showed up at the Saugus strip in 1954 driving this wild metallic-purple 1929 Ford Tudor sedan. It was powered by a hot flathead. The pin-striping was done by Von Dutch, whose eyeball logo is visible on the lower panel between the rear fenders in the above photograph. The top has a mild two-inch chop, and Chrisman has had it covered in white vinyl. Other additions include bullet headlamps from a Chevrolet, hubcaps from a 1950 Mercury, and the ever-popular 1950 Pontiac taillight lenses. Also, note the unusually shaped but very cool nerf bars at the rear. (Courtesy of Bob Richardson.)

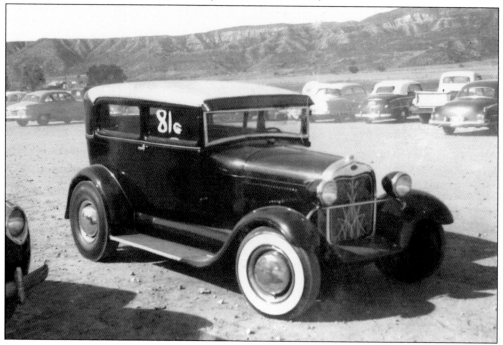

Bob Felkins, of the Motor Monarchs, built this full custom 1949 Ford Tudor coupe at his Texaco gas station on Telegraph Road in 1953. The rear end has been fully decked, with the Ford taillights completely removed, faired-over, and replaced with 1950 Pontiac lenses, moved down the body to just above the bumper. The front end has been nosed and frenched, and, except for the door handles, the body's been shaved. In those days, melted lead was used for custom bodywork instead of the filler putty used on modern cars. The car, primer gray in these photographs, would later be painted yellow. (Courtesy of Bob Richardson.)

Bob Richardson's blue-and-white 1951 Chevrolet Bel Air would be considered a mild custom by early-1950s standards. The trunk lid and rear end have been decked, and the car is equipped with a split-manifold dual exhaust system purchased from Advance Muffler in Burbank, California. Note the Silent Knights club plaque attached to the car's bumper. (Courtesy of Bob Richardson.)

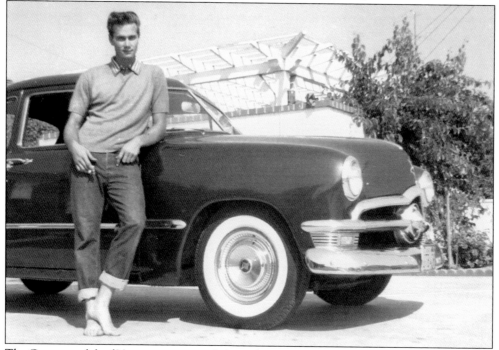

The Gents car club of Ventura was more dedicated to cruising and social events than drag racing. It was one of the better-known clubs, lasting from 1952 until the early 1960s. Here, club member Jim Bohlen poses with his 1950 Ford coupe. (Courtesy of Jim Bohlen.)

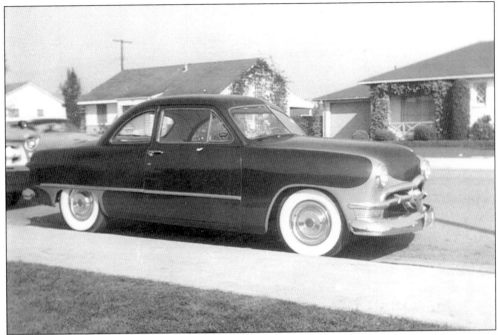

Jim Bohlen's custom 1950 Ford coupe is seen here. Nosed and decked, it was painted in a very attractive custom paint scheme of pearl maroon with silver metal flake scalloping on the front and rear. Wide whitewall tires and Mercury hubcaps made for a cool-looking mild custom. (Courtesy of Jim Bohlen.)

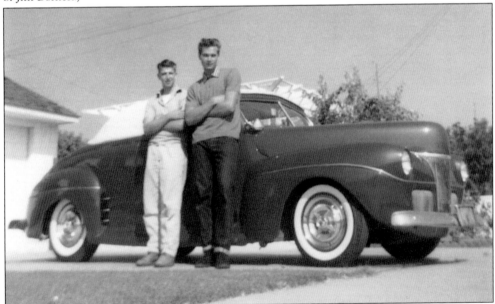

Rod Tyler (not pictured) of the Gents owned one of the best-looking customs in Ventura, this outstanding 1941 Ford convertible. Painted candy apple red with silver trim on the enhanced swage line, and sporting a white Carson top, the car has been nosed, decked, and frenched. Note the vent cut into the rear fender and the Oldsmobile "spinner" hubcaps. Jim Bohlen is pictured on the right. (Courtesy of Jim Bohlen.)

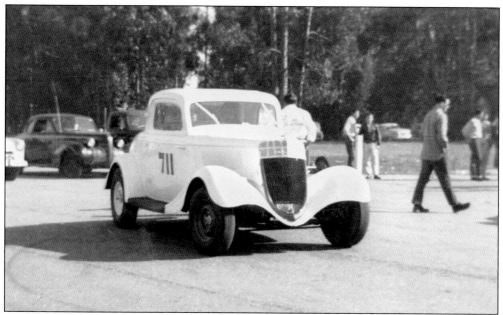

Dick Blankenship and Bill Everett of the Silent Knights ran this white 1934 Ford coupe, shown in the above photograph at Santa Maria and, below, at Saugus. Dick and his brother Harvey started working as mechanics straight out of high school, Dick at Moffett Ford and Harvey at the local Lincoln-Mercury dealership. In the photograph below, the car has gained a set of red flames. Standing in front of the car's radiator shell are local hot rodders Bill Helms (wearing hat) and Clarence "Fish" Trout (at right). (Courtesy of Bob Richardson.)

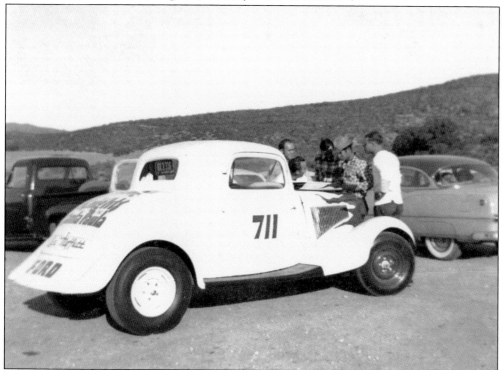

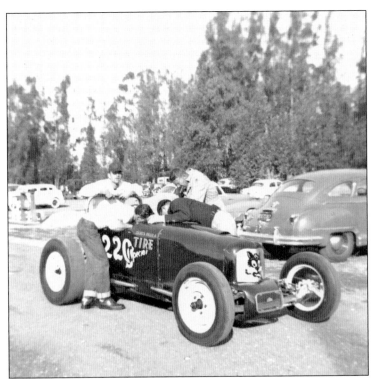

Santa Paula resident Lloyd Onstodt races with his crew at Santa Maria in 1954. The car, a combination sprint car and T-bucket bodied dragster, painted candy apple red, was one of two that Onstodt fielded in the early 1950s. Shown here are, from left to right, Don Flanagan of the Motor Monarchs, Bill Helms (wearing hat), Onstodt (smoking cigar), and Bill Welch. (Courtesy of Bob Richardson.)

Lloyd Onstodt's bobtail drag racer, the "Santa Paula Tires Special," is being pushed to the starting line at the Santa Maria drag strip staging area. Onstodt is walking alongside the car with his hand on the steering wheel, and a leather-jacketed Don Flanagan is pushing from behind on the roll bar. (Courtesy of Bob Richardson.)

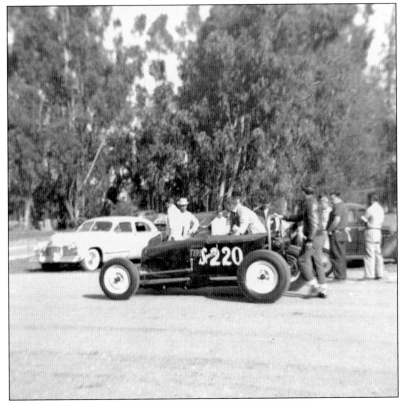

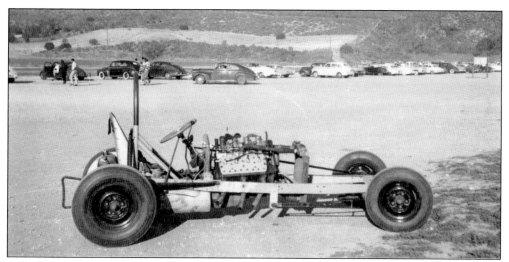

By 1954, "rails," like the one seen here at Saugus, were becoming regular sights at drag strips. A rail was basically a set of frame rails with an engine and the barest necessities for steering and suspension. The driver sat just forward of the rear axle on what appears, in this instance, to be a military-surplus airplane seat. The fuel tank is behind the seat. Protruding from behind the rear wheel is the push-bar. (Courtesy of Bob Richardson.)

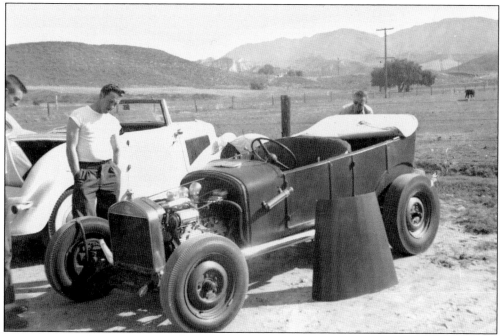

Terry Rounds of Santa Paula examines a 1927 Ford Model T Phaeton hot rod. Big open touring cars like this one were not often turned into hot rods, although this one looks pretty fast. It is powered by a dual-carb flathead with lake pipes and an old-fashioned hand pump for pressurizing the fuel system. (Courtesy of Bob Richardson.)

As secondhand overhead V-8 engines became available in the early 1950s, hot rodders lost no time installing them in their cars. This small-block General Motors engine, probably from an Oldsmobile, has been placed in a well-finished 1932 Ford Model B coupe and is equipped with four carburetors. (Courtesy of Bob Richardson.)

These three cars, all Ford products, are customized with GM taillights. They are parked at Bob Felkins's Texaco gas station in Santa Paula. Shown here are Bob Richardson's 1953, with Oldsmobile units (left), Dave Marquez's T-bucket, with taillights from a 1949 Chevrolet (center), and Felkins's Tudor, equipped with 1950 Pontiac lenses. (Courtesy of Bob Richardson.)

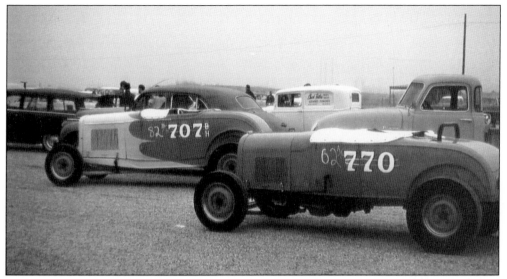

Two good-looking 1928 Ford Model A roadsters are ready to race at the drag strip in Lyons, California, in the mid-1950s. Note the attractive scalloped paint scheme on No. 707. The lettering on the panel truck in the background reads, "Chuck Peter's Body Shop, Louvers Punched." (Courtesy of Ernie Cooper.)

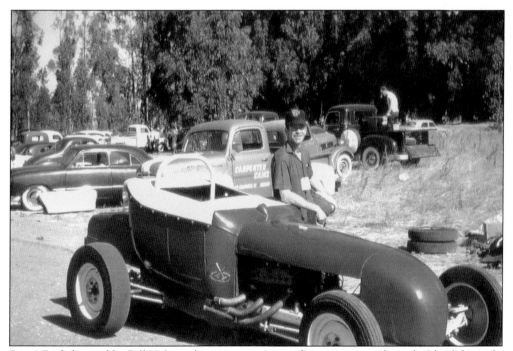

Santa Paula hot rodder Bill Helms, always seen wearing a hat, sometimes drove for Lloyd Onstodt. Typical of most of the hot rods of Ventura County, Onstot's were very well finished. Note the exhaust headers made from flex-tubing and the blunt nose cone. (Courtesy of Ernie Cooper.)

This very radical chopped, channeled, and sectioned 1932 Ford five-window Model C coupe is seen at the Santa Maria drag strip around 1954. It was painted in a pinkish-white color using primer. Note the vintage Triumph drag motorcycle in the foreground, and the GMC straight-six-powered rod at right. (Courtesy of Ernie Cooper.)

Four-door sedans were not commonly used for drag racing; roadsters and coupes were far more popular. This 1934 Ford Fordor was an exception to the rule. A roll bar is visible behind the driver's seat, and the rod has been given a coat of bright red paint, with white trim around the fenders. A bit of red overspray can be seen on the front tire. (Courtesy of Ernie Cooper.)

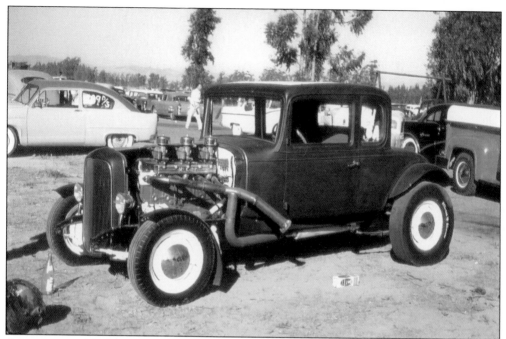

An interesting Model A sits in the littered backfield at Santa Maria. It is powered by a big GMC truck straight-six engine equipped with three Stromberg carburetors. Painted in black primer and featuring red upholstery, the car also sports a crude, homemade cut-off exhaust system. In the left background sits a Henry J. (Courtesy of Ernie Cooper.)

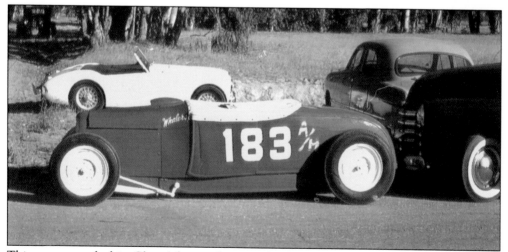

This maroon-and-white Class A hot roadster, run by the Whalers car club, has been lowered as much as possible. British sports cars were very popular in California during the 1950s. In the background sits an early Austin-Healey (left) and a more typical shoebox Ford. (Courtesy of Ernie Cooper.)

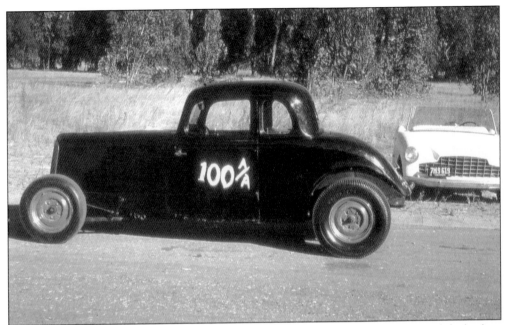

Bob Lindsay, a member of the Silent Knights, worked as a mechanic at a local Ford dealership. His channeled 1934 Ford coupe, seen here, had a blown flathead under the hood. The radiator shell is from a 1933 Pontiac. Behind it sits a Hemi-engined fiberglass kit car with a grill emulating an Aston-Martin. (Courtesy of Ernie Cooper.)

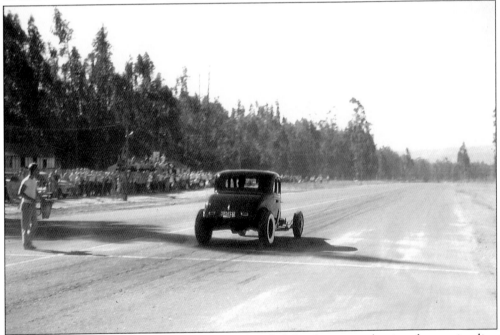

In this dramatic photograph, Santa Paula resident Bob Lindsay is just leaving the starting line at Santa Maria in his 1934 Ford coupe. Note the flagman at left. The low, wood-frame buildings visible behind the crowd were left over from the drag strip's days as an Army Air Force base during World War II. (Courtesy of Ernie Cooper.)

Bill Lindsay, a Santa Paula Lincoln-Mercury mechanic and brother of Bob Lindsay, drove this metallic-light-blue 1949 Mercury. It is seen here wearing a pair of fake spotlights. This photograph, taken at Felkin's Texaco station on Telegraph Road, shows Lindsay Lane on the right and South Mountain in the background. (Courtesy of Ernie Cooper.)

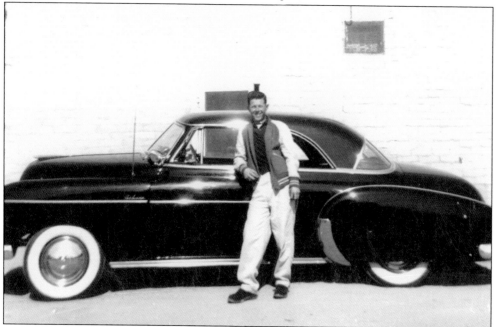

A smiling Ted Secore poses with his black 1952 custom Chevrolet Deluxe coupe behind the Martinez tortilla factory. An early member of the Motor Monarchs, Secore is proudly wearing his old-style club jacket. (Courtesy of Ernie Cooper.)

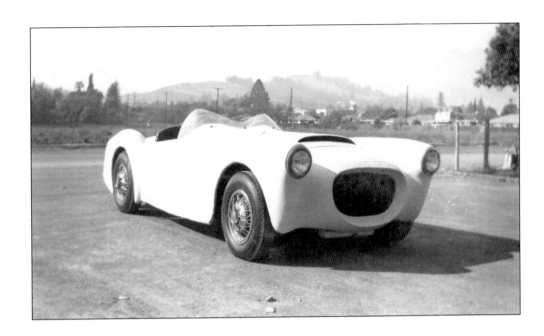

This white fiberglass-bodied sports car, or "special," was designed and built on a Ford frame by Bob Lindsay and others in Santa Paula. Cars like this could be powered by anything from a built-up Ford flathead to a GM straight-six. Jim Moody, who bought the futuristic custom, is seen in the below photograph seated behind the wheel. The car is parked in the lot of his family's business on Telegraph Road in Santa Paula. Note the simulated "wire wheel" hubcaps. (Courtesy of Bob Richardson.)

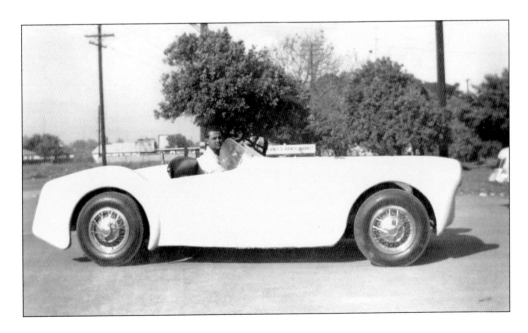

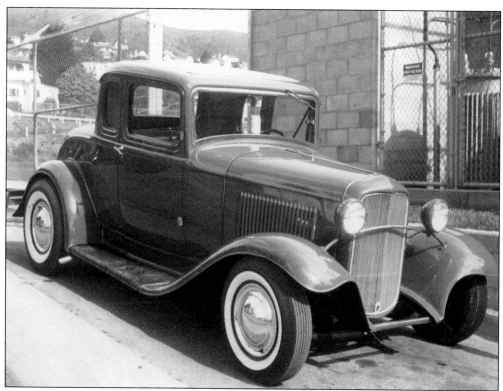

This 1932 five-window Ford Model C coupe was owned and built by Jim Harris. It had the reputation of being one of the best rods on the streets of Ventura during the 1950s. It is seen here fresh out of the paint booth of the Ventura High School automotive shop. (Courtesy of Jim Harris.)

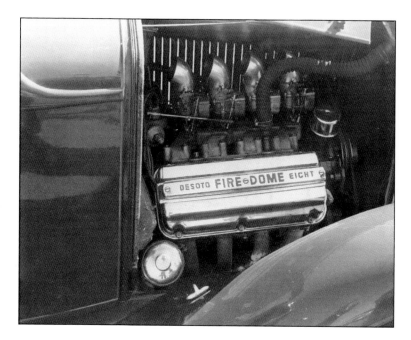

This Desoto Fire-Dome overhead V-8 powered Jim Harris's deuce coupe. He lost no time installing the engine, acquired as scrap from his father's dealership, in the Model C, which he purchased from a club in Bakersfield. Along with Ron William's Mopar, Harris's car was powered by one of the most advanced engines in the county. (Courtesy of Jim Harris.)

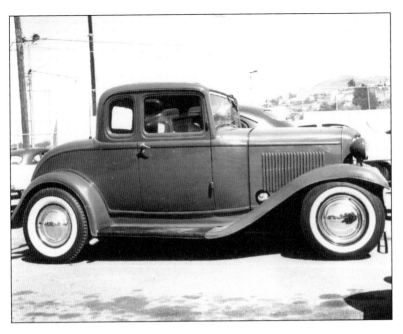

Jim Harris's classic 1932 Ford is parked behind Ventura High School in the mid-1950s. It was painted red-maroon, and in its early career wore these wide whitewall tires with Cadillac hubcaps. The interior was done in tuck-and-roll vinyl. (Courtesy of Jim Harris.)

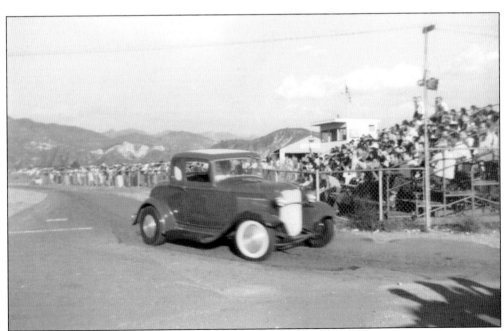

Jim Harris drives his coupe down the return road at San Fernando drag strip. An early member of the Kustomeers, Harris was out racing every weekend. He went to race at the first national drags at Kansas City and would later be asked to join the Motor Monarchs. (Courtesy of Jim Harris.)

Jim Harris raced the coupe for a few years, and then took the Fire-Dome engine and mounted it in this beautiful deuce roadster, built in his garage. Painted a deep metallic red-maroon with a white tonneau cover and radiator blank-out, this was a truly well-finished hot rod, typical of Harris's work. (Courtesy of Jim Harris.)

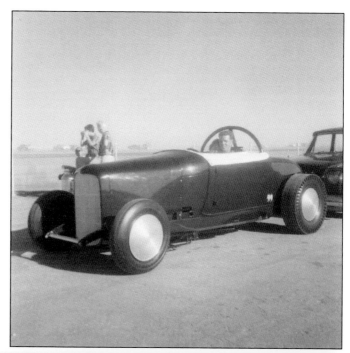

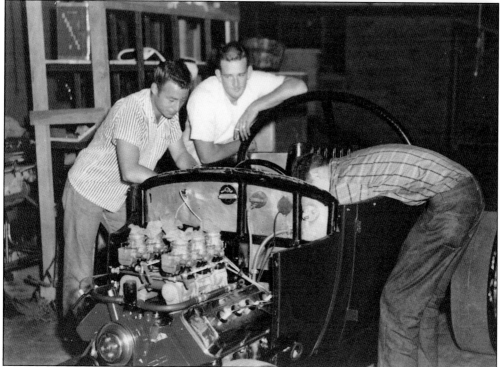

Jim Harris, seen here at right around 1958 in the garage behind his family's house, is installing the engine from his coupe into his new purpose-built drag racer. Showing mechanical aptitude at an early age, Harris started out as a lot mechanic at his father's car dealership. Also pictured in the center is Frank Floyd. (Courtesy of Jim Harris.)

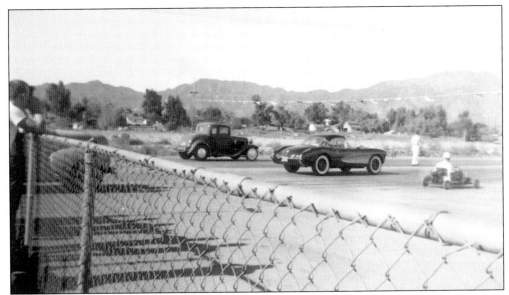

In this photograph, taken from the fence at San Fernando drag strip in the mid-1950s, Jim Harris's deuce coupe is about to race a new Chevrolet Corvette. Harris's deuce was a well-known rod at drag strips throughout Southern California. It is not clear what the go-kart at right is planning to do. (Courtesy of Jim Harris.)

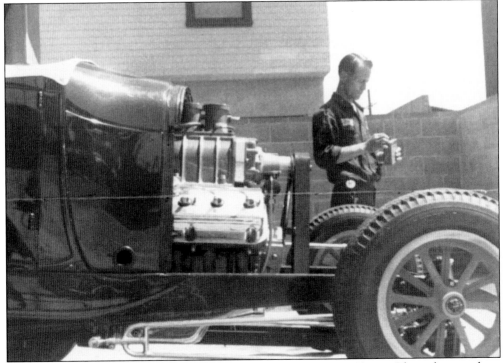

The Fire-Dome would later be equipped with a chain-driven GMC blower. The rod is seen here in the alley behind Harris Motors, on Thompson Boulevard between San Clemente and Catalina Streets. Harris would race the rod in this mode for a short time and then sell it. (Courtesy of Jim Harris.)

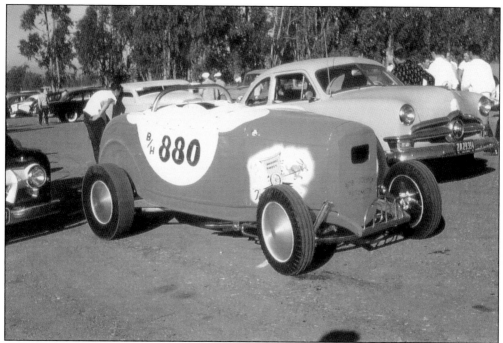

Dave Marquez's fluorescent-orange-and-white Class B Model A was considered the "King of the Roadsters" in the mid-1950s, having won the Best Appearing Car and Crew trophy at the 1955 National Drag Racing Championships in Kansas City. (Courtesy of Ernie Cooper.)

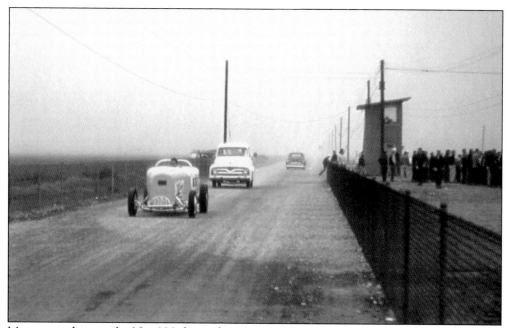

Marquez is driving the No. 880 down the return road at Lyon's drag strip, followed by Eddie Martinez in his Ford F100 pickup truck. This photograph was taken shortly after the drag strip opened. The boundary fence has been put in, but the grandstands have not yet been constructed. (Courtesy of Ernie Cooper.)

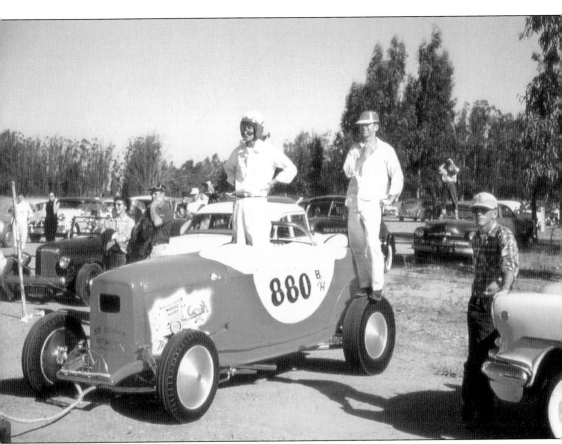

Dave Marquez (left) and Ted Secore wait at the starting line at Santa Maria for their turn to race. The image painted on the side of the engine cowl depicts a burro towing a cart with the words "Marquez Bakery" on the cart's side. (Courtesy of Ernie Cooper.)

These confident-looking young men are the Kustomeers, a Ventura club founded in 1953 and one of the most successful clubs of the era. Shown here are, clockwise from the driver's seat, unidentified, Jim Stewart, Bill McAuliffe, unidentified, Joe Alfrese, and Jim Harris. (Courtesy of Jerry Williams.)

Joseph "Joe" Alfrese, an oilfield mechanic from Foster Park, was the keeper and main mechanic of the Kustomeers' club-owned drag racer. He is seen here at left with his wife, Maryann, and son. Jerry Williams is standing at right. Note that the radiator shell has been blanked out with a piece of sheet metal. (Courtesy of Jerry Williams.)

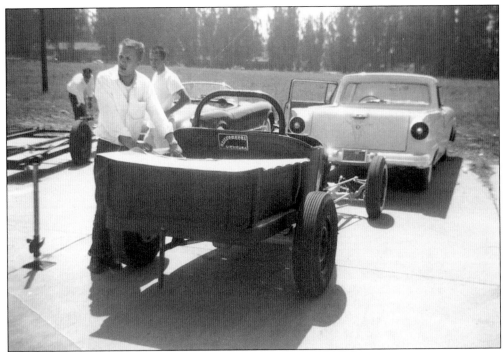

Kustomeer Jerry Williams is seen here with the club's car at Santa Maria drag strip on an August day in 1959. Note the car club's plaque attached behind the body. Some pretty cool pin-striping can be seen on the tailgate of the Ford Ranchero pickup in the background. (Courtesy of Jerry Williams.)

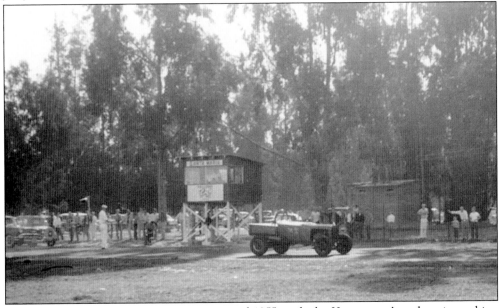

This is the starting line at Santa Maria around 1955, with the Kustomeers' roadster just taking off. At center is the timing tower, with the logo of the Santa Maria Dragons, who operated the strip, visible beneath the window. To the car's right is a concrete bunker left over from the strip's days as an Air Force base. (Courtesy of Jerry Williams.)

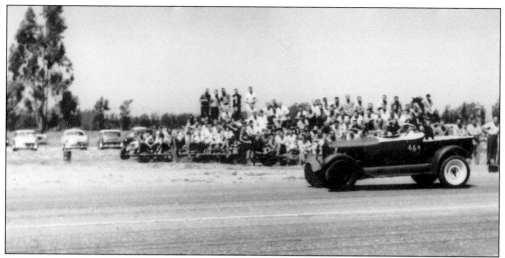

This photograph of the Santa Maria drag strip starting line was taken from next to the timing tower, looking toward the bleachers. The Kustomeers' club car is set to go on a qualifying run. The club did not have a regular driver, but instead gave each member a turn. (Courtesy of Jerry Williams.)

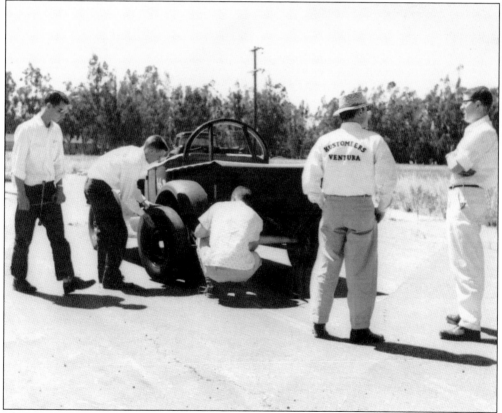

The Kustomeers' pit crew changes out the rear slicks on the club drag racer, which at this stage in its career is still wearing its fenders. The only identified person in this photograph is Kustomeer Wayne Thrift, looking on at far right. (Courtesy of Jerry Williams.)

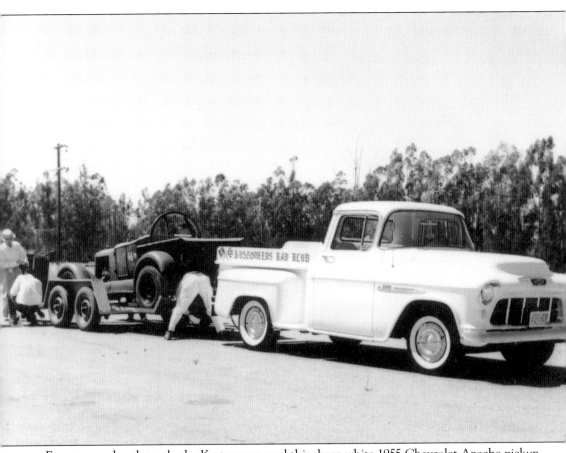

For a tow and push truck, the Kustomeers used this sharp white 1955 Chevrolet Apache pickup truck, seen here as the crew prepares to unhook the trailer for a day of racing at Santa Maria. The truck has been mildly customized, with a new grill made of chromed bar stock, whitewall tires, and boards on either side of the truck bed with the club name proudly displayed. (Courtesy of Jerry Williams.)

This photograph of Kustomeers members shows the distinctive eucalyptus groves in the background, identifying the location as Santa Maria. Shown here are, from left to right, unidentified, unidentified, Jan Plume, two unidentified, Joe Alfrese, unidentified, Tom Reed, Jim Harris, and Jim Miller. (Courtesy of Jerry Williams.)

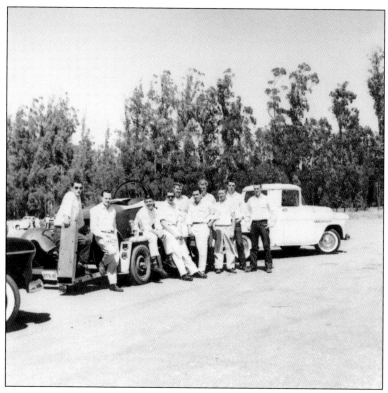

The Kustomeers' 1928 Ford Model A pickup roadster had lost its fenders by the time this photograph was taken on November 3, 1957, at Santa Maria. The body and engine are still in their original positions, and the car is painted in black primer. Standing at left is Jerry Williams, and to his right in the foreground is Bill McAuliffe. (Courtesy of Jerry Williams.)

This is a lineup of the cars from Ventura County that attended the 1956 NHRA drag races, held in Kansas City, Missouri. Parked behind the Martinez tortilla factory are, from left to right, Dave Marquez's No. 880 Speedball Spic, Richard Martinez's No. 440 coupe, Howard Clarkson's No. 550 Cyrano (all from the Motor Monarchs), and Jim Harris's 1932 custom coupe. (Courtesy of Richard Martinez.)

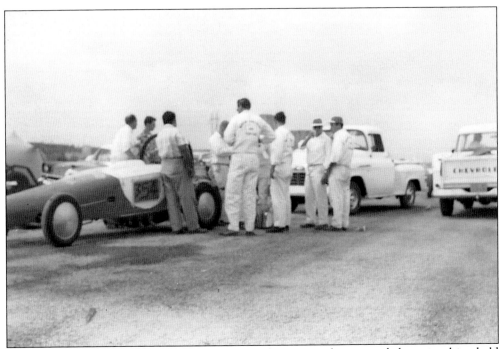

Howard Clarkson's No. 550 Cyrano is being readied to race in the national championships, held in Kansas City in 1956. The Monarchs had to use different race numbers than their accustomed double-digit series. The new numbers, issued by the NHRA, were quickly drawn on large pieces of cardboard and taped to the sides of the cars. (Courtesy of Richard Martinez.)

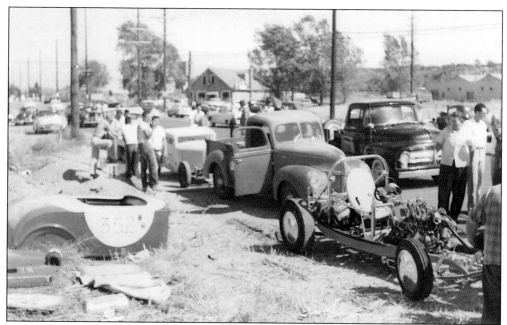

In 1956, the line to get into the nationals passed through suburban Great Bend, Kansas. In the foreground, Dave Marquez's roadster is parked and the body has been removed, no doubt in order to show off all the paint and chrome on this beautiful dragster. For the second year in a row, it won "Best Appearing Car." (Courtesy of Richard Martinez.)

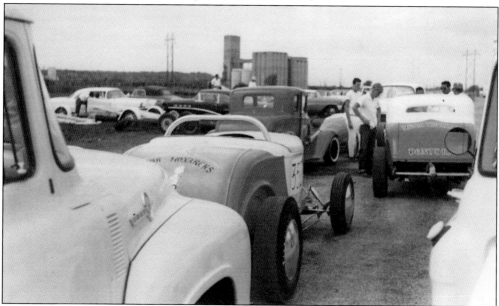

In this historic photograph, the entire Ventura County contingent is seen in the lineup to race at the national championships in Kansas City in 1956. An iconic midwestern grain silo stands in the background. In the left foreground is Eddie Martinez's Ford F-100 pickup, used as a push car. In front of that is Dave Marquez's No. 880 Speedball Spic roadster. At center is Jim Harris's Model B coupe, and just visible ahead of it is Howard Clarkson's No. 550 Cyrano. To the right is Richard Martinez's No. 440 coupe. (Courtesy of Richard Martinez.)

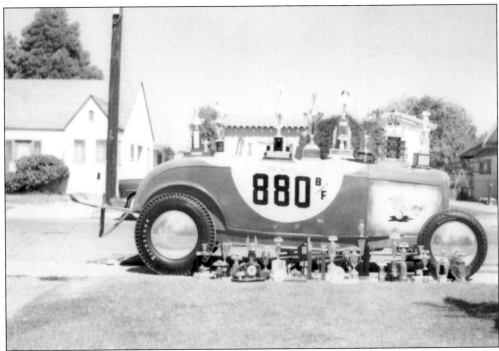

Dave Marquez's famous B/F roadster, the No. 880 Speedball Spic, is seen back home in Santa Paula, surrounded by its many trophies. (Courtesy of Richard Martinez.)

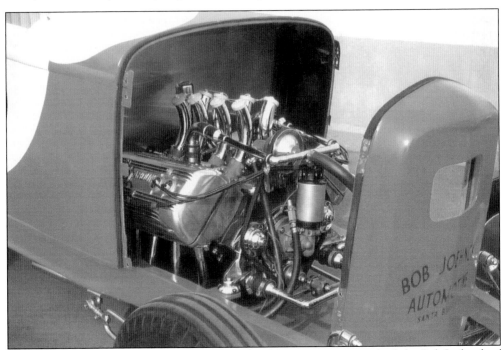

Dave Marquez's remarkable 276-cubic-inch Ardun-Mercury engine was built by Bob Joehnck of Santa Barbara. Based on a 1949 Ford block, it was bored and stroked and fitted with an Iskenderian cam. It also was equipped with a Hilborn fuel-injection system. (Courtesy of Ernie Cooper.)

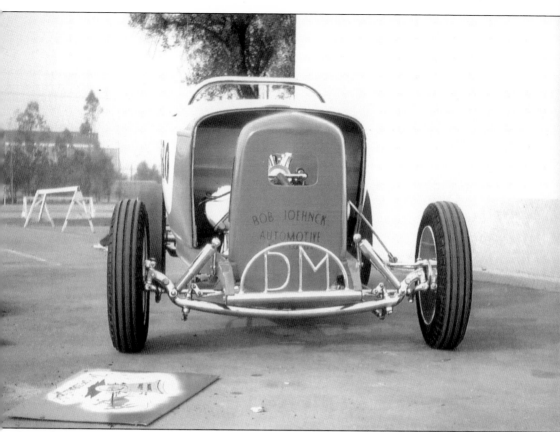

In 1956, Marquez's roadster was exhibited at the Motorama car show, held at the Pan-Pacific Auditorium in Hollywood, California. This front view shows Marquez's famous monogram nerf bar, which was also featured on his previous drag racer. In the background is the newly built CBS Television City. (Courtesy of Ernie Cooper.)

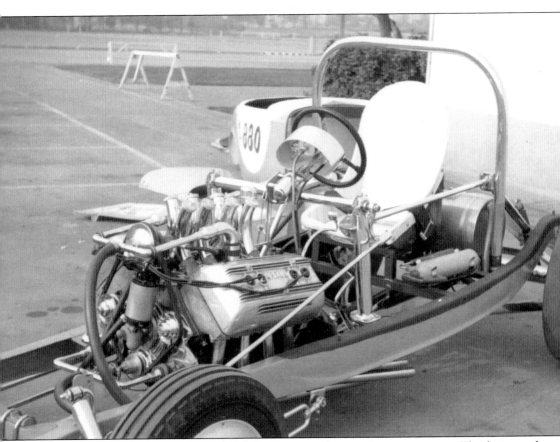

Dave Marquez's No. 880 was considered an innovative dragster for many reasons. The design and engineering were first-rate, especially where driver safety was concerned. Its superb fit and finish were unlike any dragster before it. All nonmoving parts were either painted or chrome-plated. (Courtesy of Ernie Cooper.)

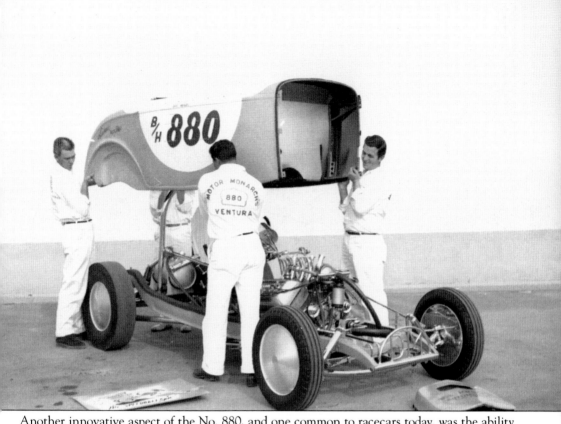

Another innovative aspect of the No. 880, and one common to racecars today, was the ability to remove the car's body in minutes by manipulating a few fasteners. Seen here holding up the all-steel body, are, from left to right, Dorr Thayer, unidentified, Ben Martinez, and Howard Clarkson. (Courtesy of Ernie Cooper.)

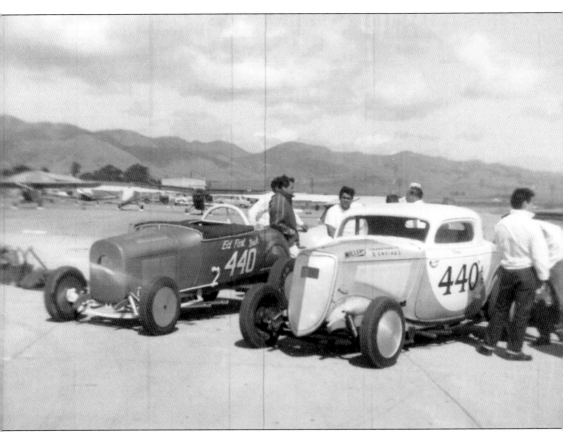

In 1956, after many successful years racing the No. 440 roadster, the Motor Monarchs sold the historic dragster to the Smokers, from Bakersfield, California. The car (left) is seen here at the San Luis Obispo drag strip being prepared to race its replacement, a 1934 Ford coupe built by Richard Martinez. The new drag racer was originally raced without fenders. (Courtesy of Richard Martinez.)

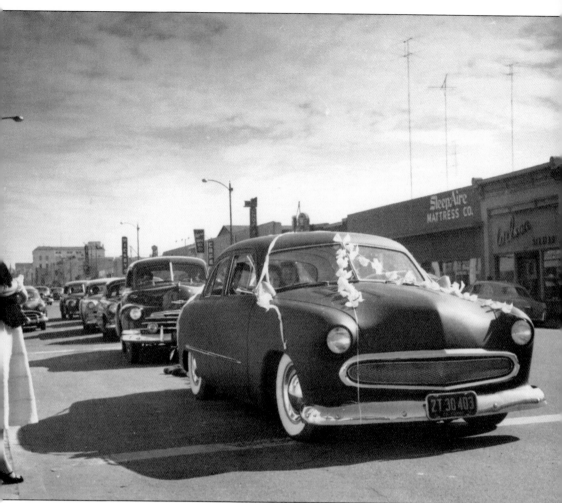

This customized 1954 Ford, powered by a blown flathead engine and owned by Richard Martinez, was dubbed the "Vacuum Cleaner" because of the blower's whine. The car is seen here late one afternoon on Main Street in front of Mission San Buenaventura, all decked out for a wedding. (Courtesy of Richard Martinez.)

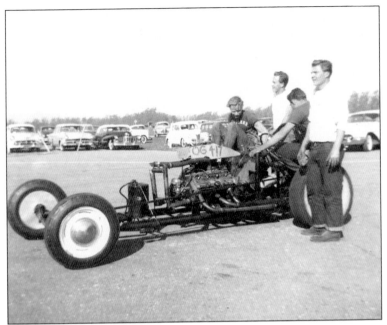

This rail, pictured at Santa Maria in 1957, shows some of the technological advancements that took place in dragster design over just a few years. An engineered frame of welded steel tube has replaced the Model A frame rails. The radiator has been eliminated to save weight, and the fuel tank has been moved ahead of the engine. (Courtesy of Bob Richardson.)

Car clubs in Ventura would build hot rods and customs one after the other and trade or sell them back and forth. Here, Kustomeers members Bob McElvoy (left), Kenny Partain (center), and Tom Reed work on a custom 1947 Ford Club Coupe that would be sold to Motor Monarch C. Darryl Struth. (Courtesy of Jerry Williams.)

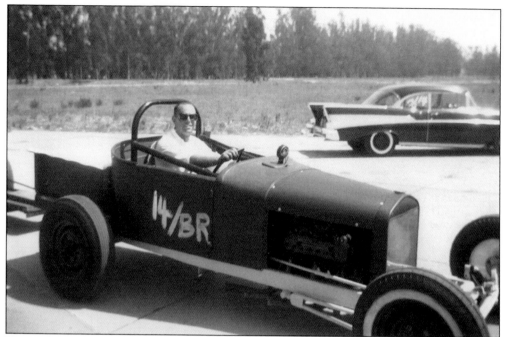

This is the Kustomeers' Class B roadster in its final incarnation. The car's body has been moved to the rear of the frame, so the driver sits just forward of the rear axle. A 1949 Mercury flathead is under the hood, and a tachometer is mounted on the cowling ahead of the driver. Kustomeer Edwin "Ed" Frank is seated behind the wheel. (Courtesy of Jerry Williams.)

Stock class drag racers could be very successful, as shown by this completely stock Chevrolet owned and raced by Mike Bernard of the Kustomeers. The 1956 Del-Ray coupe was purchased new by Bernard and was powered by a stock 283-cubic-inch V-8 with a four-speed stick transmission. (Courtesy of Jim Monahan.)

Kustomeers member C. Darryl Struth ran the paint shop for the missile test center at nearby Point Mugu Naval Air Station. In 1957, the Motor Monarchs invited him and two others from the Kustomeers, Jim Harris and Bill Tudor, to become members. Struth was made vice president of the club, a title he still holds today. (Courtesy of C. Darryl Struth.)

Pictured here parked across the street from Merle's Drive-In is C. Darryl Struth's Ford Victoria. It was painted black, with a white cover on the roof and gold metallic Plymouth Fury upholstery. It rode on a set of whitewall tires mounted on steel wheels with baby Moon hubcaps. The building in the background is the old department of motor vehicles. (Courtesy of C. Darryl Struth.)

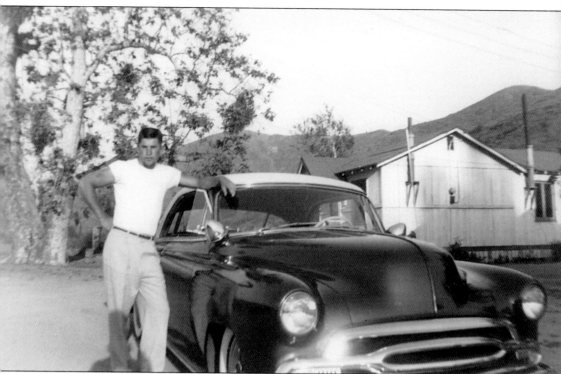

The Coachmen, founded in 1956, were one of Ventura's larger clubs. Like many clubs, it built and successfully raced a Model A drag racer at Santa Maria and Bakersfield. Club president Ernie Sawyer poses with a custom maroon-and-white 1950 Chevrolet coupe owned by club member Roger Lingbecker. Besides the Cadillac hubcaps and custom grillwork, this car has fake spotlights on either side of the windshield, a styling touch seen on many 1950s customs. (Courtesy of Ernie Sawyer.)

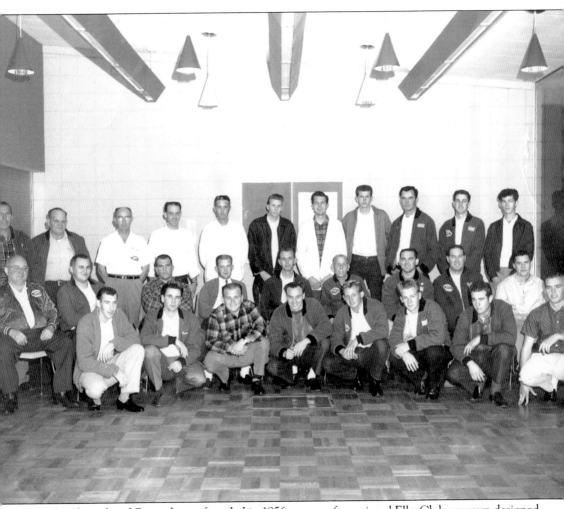

The Pharaohs of Oxnard were founded in 1956 as part of a national Elks Club program designed to foster "good guy" car clubs. Originally called the T-Timers, as were all the clubs founded under the program, Oxnard members became dissatisfied with the Elks' administration of club business and left to form the Pharaohs. (Courtesy of Bud Hammer.)

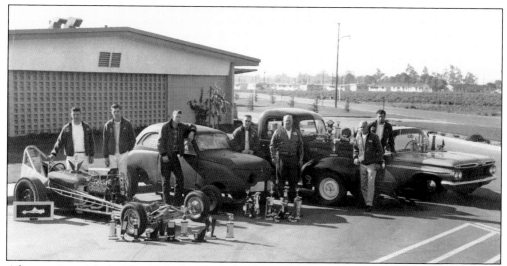

After parting with the Elks Club, the Pharaohs received the unofficial sponsorship of the Oxnard Police Department and moved their meetings to the Oxnard Community Center. This lineup of club members and supporters shows a variety of 1950s and street rods as well as the club dragsters. (Courtesy of Bud Hammer.)

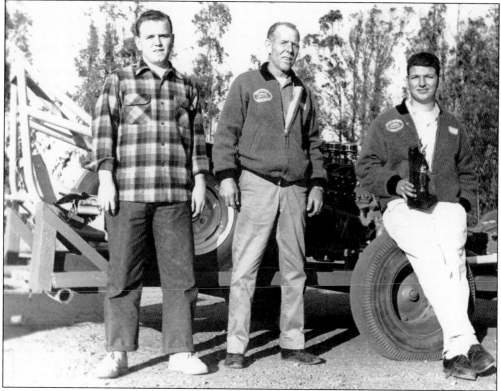

Among the most active members of the Pharaohs were Bud Hammer Jr. (left), Bud Hammer Sr. (center), and Nick Sweetland. Seen here after a successful day racing at Santa Maria, they are posing with the Hammers' flathead-powered gasser. Buddy and Nick are still active in the Heritage Drag Racing scene. (Courtesy of Bud Hammer.)

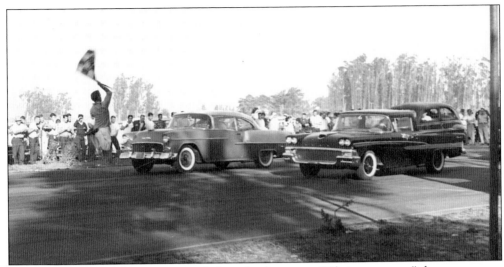

In the days before elaborate starting lights, also known as "Christmas trees," drag races were started by guy waving checkered flags called, obviously, flagmen. Some of them made the waving of the flag an art form. This flagman, at Santa Maria in the late 1950s, becomes airborne starting a duel between a Ford and a Chevrolet. (Courtesy of Bud Hammer.)

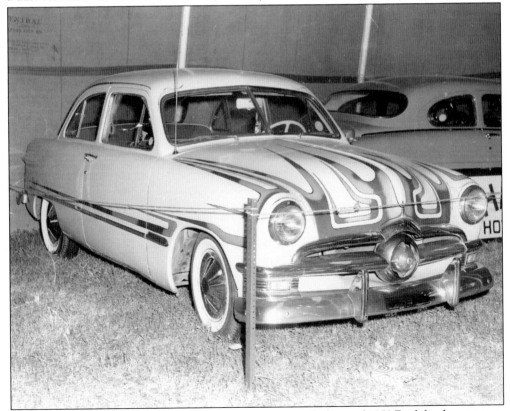

Nick Sweetland, when he wasn't working on his dragster, built this cool 1950 Ford shoebox custom. Seen here in 1957 at the Oxnard Sports Festival, it is wearing a classic late-1950s paint scheme of canary yellow with green and silver stylized flames. The hubcaps are from a Studebaker.

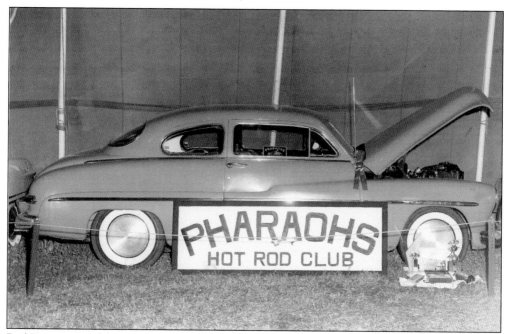

Bud Hammer's mild custom 1950 Mercury could also be called a street rod. Although it has been nosed and decked, most of the attention has been paid to the engine. The Mercury block was bored and stroked and then was equipped with Offenhauser heads, four Stromberg carburetors on a Navarro intake, and a duel-coil ignition. (Courtesy of Bud Hammer.)

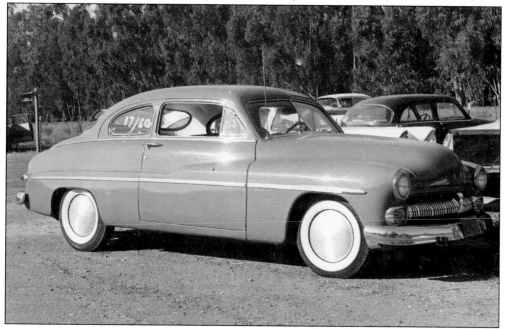

After putting so much work into the Mercury's engine, Buddy Hammer naturally wanted to race it. He did race, as seen here at Santa Maria, where he ran the street rod in "B" class. This 1950 coupe was painted in an eye-popping scheme of bright orange with a black-and-white tuck-and-roll interior. (Courtesy of Bud Hammer.)

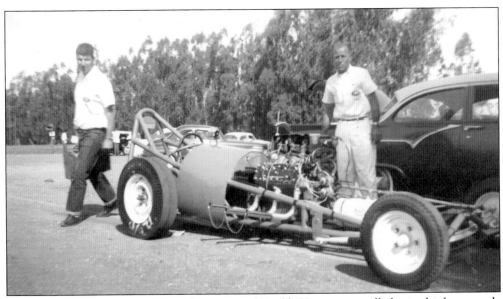

After racing the Mercury engine in his street rod, Buddy Hammer installed it in this homemade tube frame. The frame was built by an airman at nearby Oxnard Air Force Base, who fabricated it from heavy industrial pipe and sold it to Nick Sweetland. It was painted in the same color as Hammer's Mercury, orange. (Courtesy of Bud Hammer.)

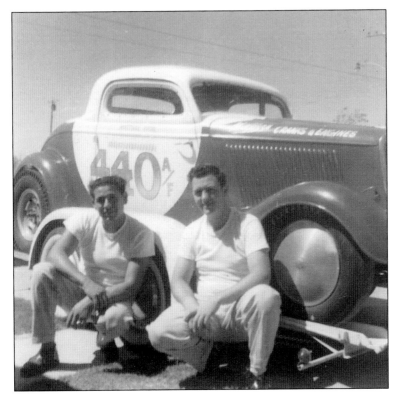

Richard Martinez's new No. 440 Class A fueler was powered by a blown Cadillac engine, built by Martinez. In 1958, when this photograph was taken, the car had acquired a set of fenders. The top was chopped four inches. Martinez (left) poses with Howard Clarkson. (Courtesy of Richard Martinez.)

Painted the Monarchs' colors of orange and white, the new No. 440 exhibits the excellent finish and appearance the Martinez brothers were famous for. The lettering was done in gold leaf by Richard and Eddie's father, and Richard cut 150 louvers into the steel trunk lid and rear fenders. The steel wheels wore full Moon disc hubcaps. (Courtesy of Richard Martinez.)

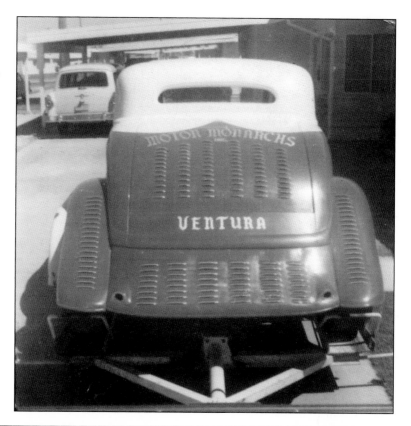

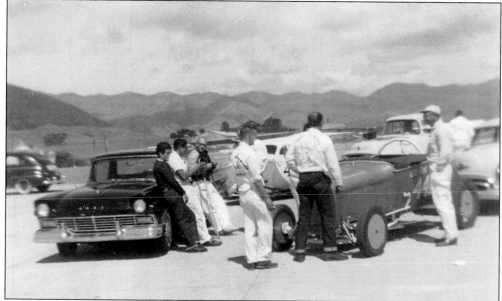

Richard Martinez (second from left) leans on his 1957 Ford Ranchero tow truck. Just visible in the center is the No. 440 coupe. To the right is the original No. 440 roadster. It has been repainted in the Smokers' club color, metallic lavender, but has retained the race number 440. It has also acquired a roll bar. (Courtesy of Richard Martinez.)

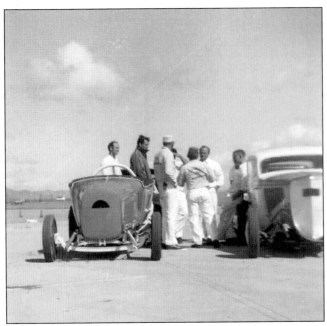

Later, in 1958, Martinez raced the new No. 440 against the old No. 440 at San Luis Obispo, seen here. They dueled for Top Eliminator, and the coupe won. After long service with the Smokers, the original No. 440 was sold off. Its current whereabouts are unknown. (Courtesy of Richard Martinez.)

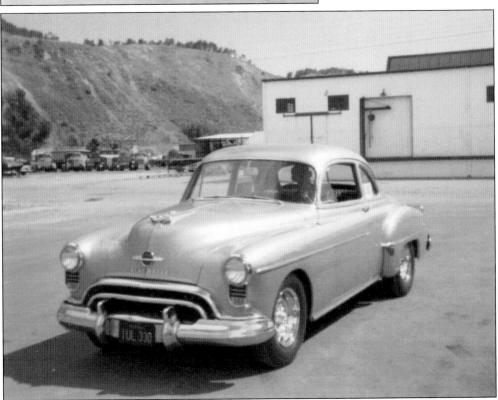

The late-1940s and early-1950s models of the Oldsmobile Rocket 88 were popular with hot rodders because of the great styling and Rocket overhead V-8 under the hood. This coupe, parked somewhere off of Ventura Avenue, was owned and mildly customized by Richard Martinez. (Courtesy of Richard Martinez.)

The car was painted metallic gold and had black vinyl tuck-and-roll upholstery. The dashboard was black lacquer with gold dust sprinkled on it under a clear coat, achieving a metallic effect. Richard Martinez tweaked the Rocket V-8 by adding a roller cam. Note that it has a stick shift instead of the more common column shift. (Courtesy of Richard Martinez.)

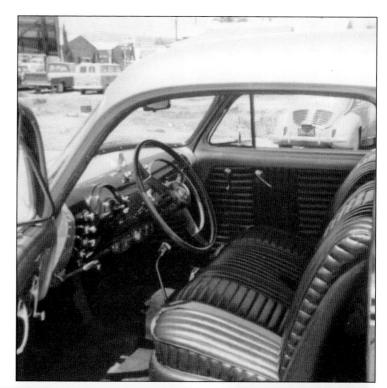

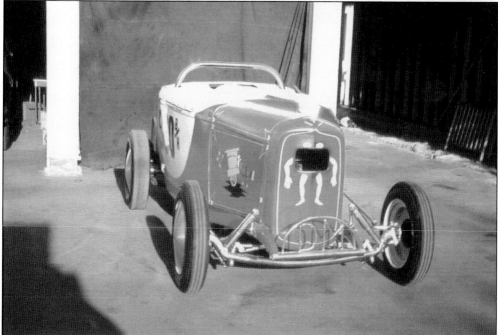

In 1957, Dave Marquez had Von Dutch pin-stripe and re-letter the No. 880 in return for a bottle of vodka, so the legend goes. A short time later, the roadster's long-lived Ardun engine was blown while the car was being driven by Jack Chrisman at Famoso drag strip in Bakersfield, California, and the historic drag racer was retired. (Courtesy of Ernie Cooper.)

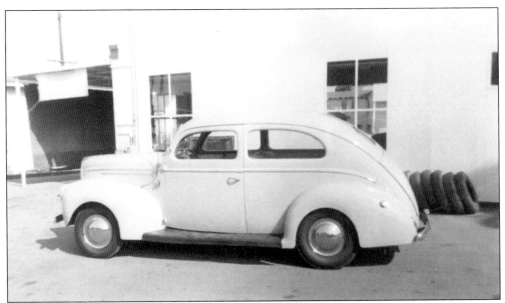

Marvin "Marv" Houghton, of the Gents car club, owned this deceptively plain 1939 Ford deluxe coupe. Painted in Cadillac powder blue, it was powered by a Mercury AB flathead built by Bob Ellsworth and was equipped with Offenhauser heads and an Iskandarian cam. The car is seen here parked behind Taylor's Polly service station on Meta Street. (Courtesy of Marvin Houghton.)

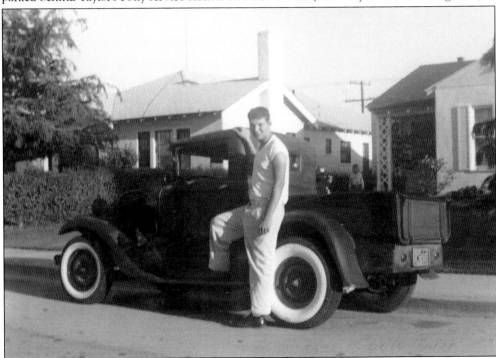

Nick Sweetland's first rod was this chopped 1932 Ford pick-up, seen here in 1957 in front of his parent's house on Deodor Street in Oxnard. The primer-black truck would soon be sold. It still exists today in an Oxnard garage, although it has sat in a disassembled state for nearly 40 years. (Courtesy of Nick Sweetland.)

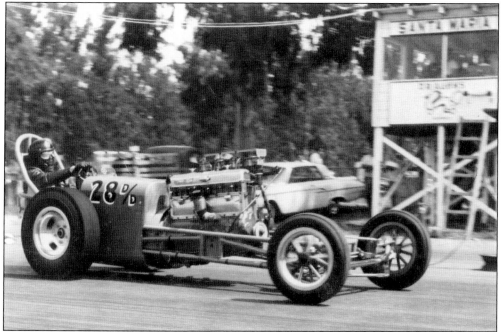

Class D dragsters, powered by straight-six or straight-eight engines, were not common. This one, owned and driven by Buddy Hammer, is running a 320-cubic-inch GMC truck engine equipped with an Isky cam and four carburetors on a homemade intake. (Courtesy of Bud Hammer.)

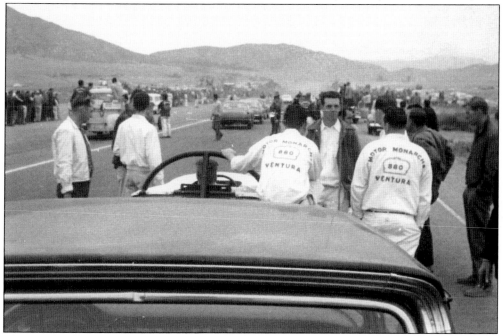

The Motor Monarchs continued to race into the late 1950s. Seen here at Riverside are former Kustomeers C. Darryl Struth (hand on roll bar), Jim Harris (in jacket, facing camera), and Bill Tudor (with back to the camera). Their Motor Monarchs pit crew shirts were seen at drag strips throughout California. (Courtesy of Jim Harris.)

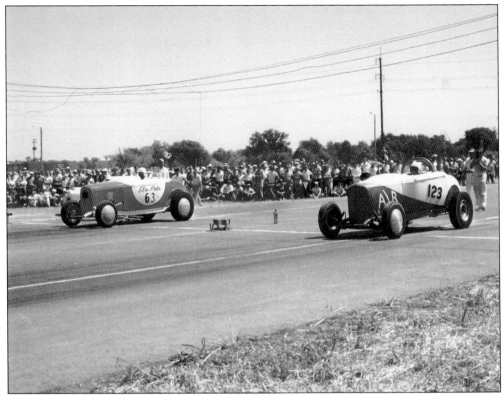

Dave Marquez sold the engineless No. 880 around 1959 to a buyer in the state of Georgia. As seen in this mid-1960s photograph, the historic dragster has been renamed "Slo-Poke" but is still wearing its orange and white colors. In later years, it was reportedly painted green and later disappeared from sight. There are rumors that it is stored somewhere in the Southeastern United States. (Courtesy of C. Darryl Struth.)

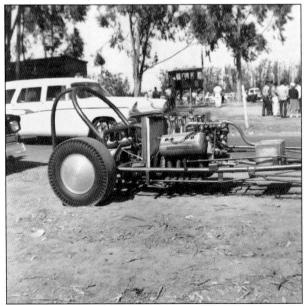

This dragster, seen at Santa Maria around 1960, shows what a typical homemade dragster looked like. It is powered by an Ardun-Ford overhead conversion mounted on a very simple tube frame that appears to be quite crudely welded. The fire wall is a large square sheet of metal fastened by pieces of angle stock, and the early "roll cage" doesn't look like it affords much protection. (Courtesy of Bud Hammer.)

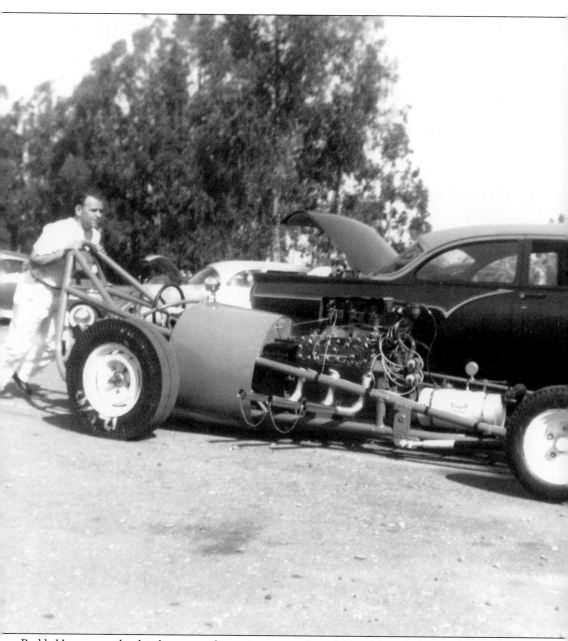

Buddy Hammer pushes his dragster to the staging area at Santa Maria. Here, the heavy construction of the frame is shown to better advantage. Soon, companies like Chassis Research and Drag-Master would design and produce lightweight and professionally made frames, making it relatively easy to assemble a competitive drag racer. (Courtesy of Bud Hammer.)

As NHRA classifications evolved through the early 1960s, Porsche-engined Volkswagens fielded by EMPI started a whole new class of dragsters. Bud Hammer took advantage of this by squeezing his built Mercury flathead into this tiny 1946 Crosley. It was painted in Hammer's customary bright orange color. (Courtesy of Bud Hammer.)

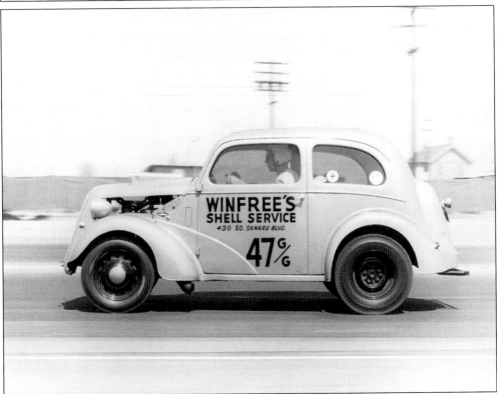

As the new G classification caught on, drag racers began installing V-8 engines into small European cars like Fiats and English Fords. Charles Winfree and Harley Barrett of Oxnard built what was probably the first Ford Anglia–bodied drag racer to ever see competition. Dragsters like this metallic-gold-painted "G" gasser would evolve into the Funny Car class by the mid-1960s. (Courtesy of Bud Hammer.)

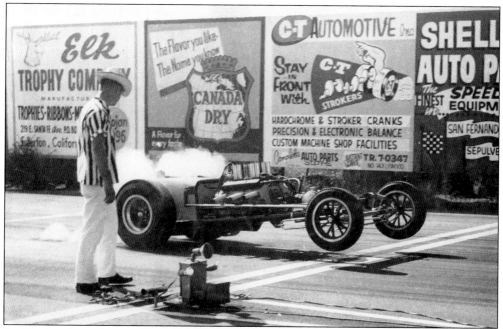

In this shot from the early 1960s, Nick Sweetland is pulling a wheelie in his fueler, "Eloise," off the starting line at San Fernando. The starting light array in the foreground would soon evolve into the large multi-light systems called "Christmas trees." (Courtesy of Nick Sweetland.)

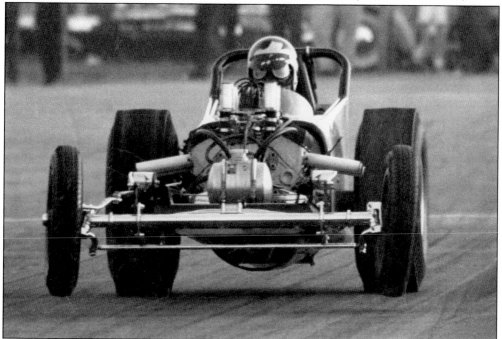

A master at the wheel-stand, or wheelie, Nick Sweetland is shown here lifting off at Fontana drag strip around 1965. His gasoline-fueled dragster was powered by a 301-cubic-inch Chevrolet small block engine with Hilborn fuel injection. Note how the dragster's front suspension differs from earlier ones, like Bud Hammer's GMC-powered Class D dragster. (Courtesy of Nick Sweetland.)

This photograph of Nick Sweetland posing with Bud Hammer's dragster at Santa Maria shows the car's Mercury flathead to good advantage. Note the Offenhauser heads and the lineup of four Stromberg carburetors. The chromed straight-exhaust headers have an interesting alignment. (Courtesy of Nick Sweetland.)

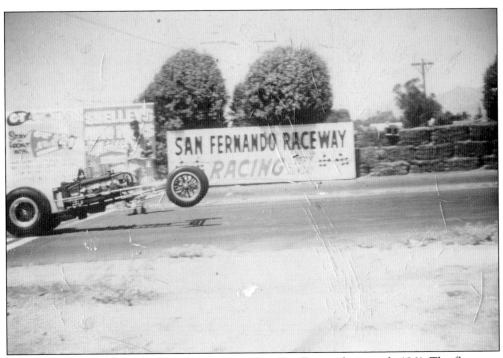

Here is another shot of Nick Sweetland taking off at San Fernando, in early 1961. The flagman, seen standing at left by the starting line, no longer waves a checkered flag, but uses a hand control to operate the starting lights. At right, a safety barrier made of hay bales can be seen. (Courtesy of Nick Sweetland.)

These photographs depict the last time the Martinez brothers went racing, at Bakersfield, in 1961. They were testing yet another blown Cadillac engine, of Richard's construction, this one with 420 cubic inches. The brothers had come full circle and were back in the car that started it all, the original No. 440. Richard borrowed the 440 from the Smokers, and it is seen here in club colors. Note the cool-looking shirts that Richard's pit crew is wearing. (Courtesy of Richard Martinez.)

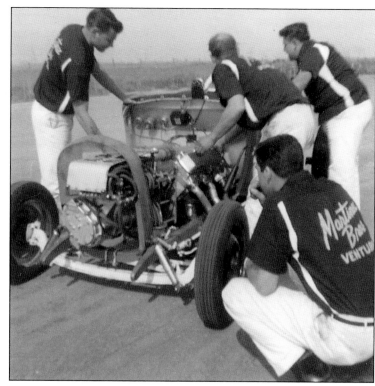

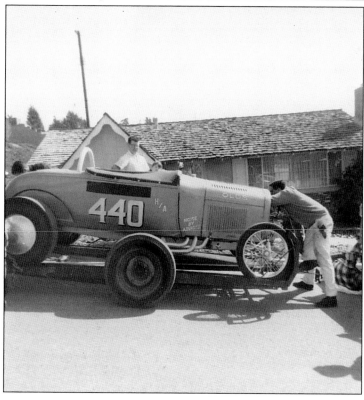

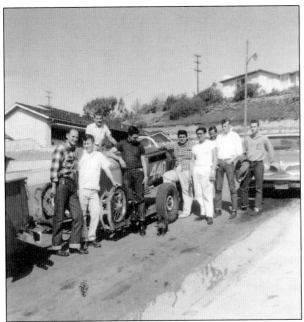

Richard and Eddie Martinez pose with other Monarchs at Eddie's house on Arnett Street in Ventura, after the run. Robert Olinger is at far right, and Richard and Eddie are fourth and fifth from right by the 440's cockpit. (Courtesy of Richard Martinez.)

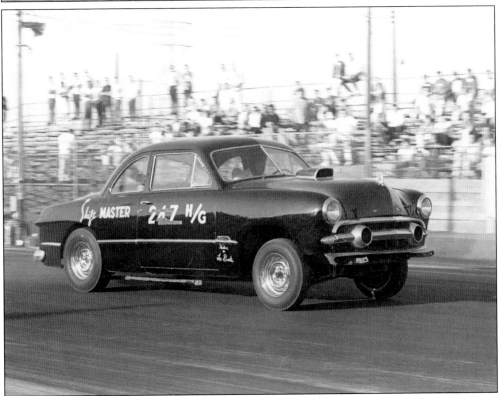

Jack Taylor of the Pharaohs raced a black 1949 Ford coupe, the "Shift Master," throughout the early 1960s. Classed as an "H" gasser, this early funny car is seen leaving the starting line at Long Beach in 1961. The car's sponsor, Ben Ryan, owned Shift-Master, which manufactured high-performance shift conversion kits. (Courtesy of Jack Taylor.)

The Shift Master was co-owned by Jack Taylor (left) and Charles Winfree (center). Standing at right is Terry Hedrick, who would later gain fame racing funny cars. The Shift Master was powered by a fuel-injected 296-cubic-inch flathead. (Courtesy of Jack Taylor.)

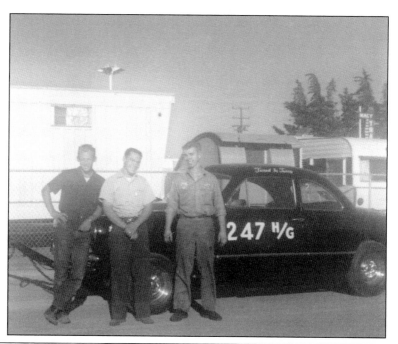

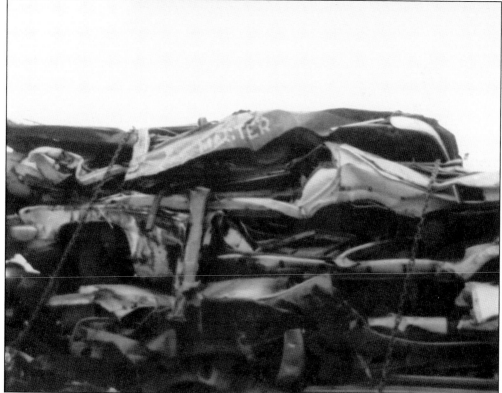

The Shift Master met with the same unfortunate fate as most of the hot rods, customs, and dragsters highlighted in this book: a trip to the junkyard. Seen here strapped to the back of a scrapper's truck, it was probably reborn as a Honda or Toyota. (Courtesy of Jack Taylor.)

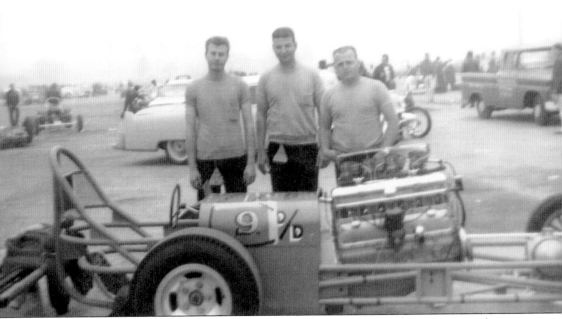

The 1963 NHRA winter national championship, or Winternationals, was a seminal event in the history of drag racing. Held at Pomona, California, it introduced a whole new generation to the sport. Ventura County was represented by Fred Notzka (left), Nick Sweetland (center), and Buddy Hammer, all members of the Pharaohs of Oxnard. Hammer's big GMC-engined dragster competed well, but dropped out due to a loose flywheel. (Courtesy of Bud Hammer.)

Four

PEOPLE AND PLACES

The dean of the Ventura hot rodders, Ambrose "Amby" Little, is seen here in a typical pose at the body and paint shop he co-owned, Buena Body Shop, on Thompson Avenue. A founding member of Ventura's first car club, The Slug Slingers, in 1937, he was also a participant in the prewar meets at El Mirage Dry Lake, and was an early pioneer of hot rodding. After serving in Europe as a tractor mechanic for an artillery company with the Army in World War II, Little returned to Ventura, where he began a successful career as an auto-body mechanic and businessman. As he began raising a family, he no longer raced, but remained active in the scene. A much-loved and respected figure in the racing community, Little was always ready to give help, advice, and occasionally a job to Ventura hot rodders. (Courtesy of Ambrose Little.)

A skilled body and paint man, Amby Little customized this 1950 Ford Tudor as his personal car. The headlights have been frenched and a ridge has been added along the hood. The grill bars are from a Plymouth. After shaving the body, Little reversed the trim pieces from a Ford Crestliner and mounted them on the sides. The wheels sported white sidewall tires and Oldsmobile hubcaps. Little finished the car in black paint, with gray trim around the windows. (Courtesy of Ambrose Little.)

A popular hangout and meeting place for the Kustomeers was American Welding, at 1070 Ventura Avenue. Owned and operated by the Monahan family since 1928, the shop mainly serviced the oil industry. Family member Jim Monahan was a charter member of the Kustomeers and later became prominent in Ventura city government.

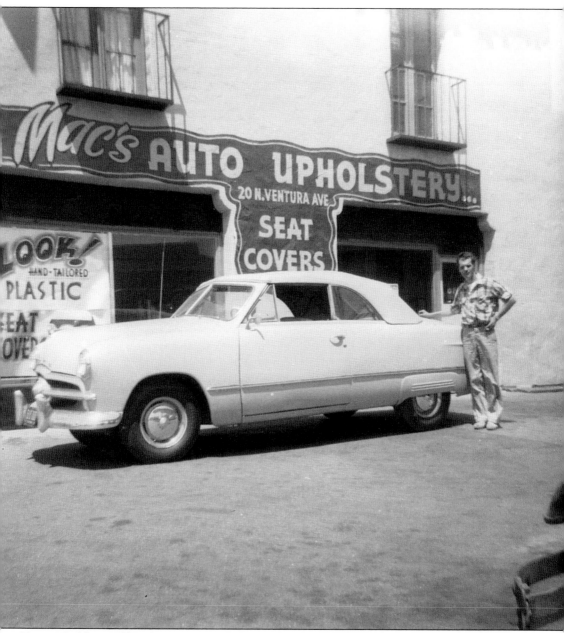

Ventura's oldest and best-known auto upholstery shop, Mac's Upholstery, has been in business for over 60 years. Founded by "Mac" Maclaren, the shop covered the seats and interiors of many local hot rods throughout the 1940s and 1950s, as it does today. Originally located at 20 North Ventura Avenue, the shop was moved to its current address in a historic building at 1241 East Thomson when redevelopment changed the face of the avenue in the 1970s. The business is operated today by Mac's son, Paul Maclaren, also well known for building and racing off-road vehicles. Paul was a member of the late-1950s Ventura car club the Red Devils. (Courtesy of Paul Maclaren.)

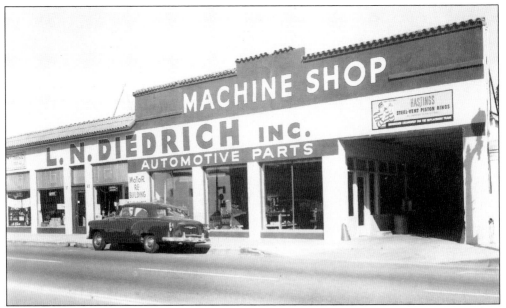

L.N. Diedrich Inc. was well known in the Ventura automotive business community as an after-market parts supplier and machine shop. Many local hot rodders worked there at one time or another, most notably Ron Williams. It was located on Thompson Avenue, west of Seaward Street. (Courtesy of Dennis Williams.)

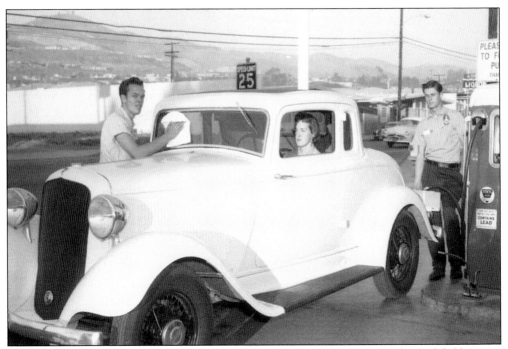

Seen here polishing the window of his sister's yellow 1933 Plymouth coupe at the Richfield service station, located at 2909 Loma Vista, is Gents member Marv Houghton. Behind the wheel is Marv's sister, Marilyn, and to the right is Marv's future bother-in-law, Keith Baker. The Ventura landmark Five Trees is visible in the upper-left background. (Courtesy of Marvin Houghton.)

Marv Houghton would go on to a long, successful career with the Ventura Police Department, rising to the rank of captain. He is seen here astride a vintage Harley-Davidson on Meta Street. Although the clubs of Ventura had a good relationship with the local police, there was one officer, nicknamed "Red Ryder" after a Western comic book lawman, who seemed to have a personal grudge against hot rodders. He was well known and disliked by everyone on the scene in the 1940s and 1950s. (Courtesy of Marvin Houghton.)

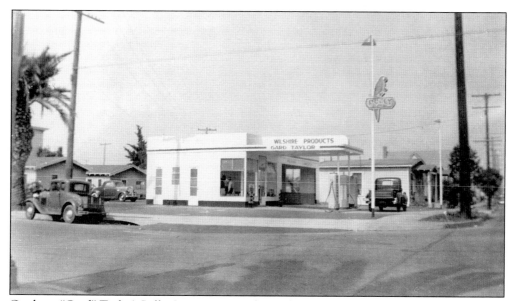

Gardiner "Gard" Taylor's Polly Gas station was located at 292 East Meta Street, on the corner of Palm Street, and sold products from the Wilshire Oil Company. The brand-new service station, seen here, was on a stretch of Meta Street that would later become part of Thompson Avenue. (Courtesy of Marvin Houghton.)

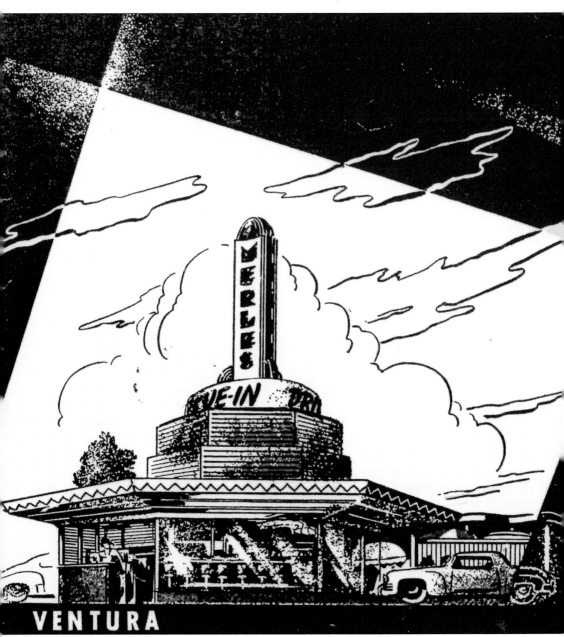

VENTURA

Merle's Drive-In was the center of social life for hot rodders throughout the 1950s. Located at the Five-Points intersection on the east end of Ventura, it was also the starting point for Saturday-night cruising, or "running the drag," as the locals called it. Running the drag would start at Merle's, go west on Main Street past the high school and Cemetery Park, and wind up in old town at the Mission, where everyone would turn around and reverse the route. Heine's Pool Hall and other Main Street attractions were various stopping points along the way. Other destinations might be a trip north on Highway 1 to Carpenteria to watch the jalopy races at the Thunderbowl Racetrack, or up to Santa Barbara for hamburgers at the Blue Onion Drive-In. Merle's was demolished in the early 1960s. (Courtesy of Wanda Nelson.)

The Ventura Community Center (also known as the Ventura Bath House), at the end of California Street by the pier, was a popular meeting spot for local hot rodders over several decades. It can be seen in the background in this shot of bathing beauty Wanda Nelson, posing on her Dodge sedan. (Courtesy of Wanda Nelson.)

No history of drag racing would be complete without a mention of the "trophy girls." Fixtures at all the drag strips during the 1950s and 1960s, these ladies were on hand to give out the trophies to the fortunate winners at the end of the drag meet. This trio is pictured at Santa Maria. (Courtesy of Ernie Cooper.)

Lloyd Onstodt, pictured here, was a well-known businessman, antique car restorer, and drag-racing enthusiast. Owner of Santa Paula Tires and a county fireman, Onstodt fielded two dragsters, one of them the flathead-powered T-bucket seen here at Santa Maria. (Courtesy of Ernie Cooper.)

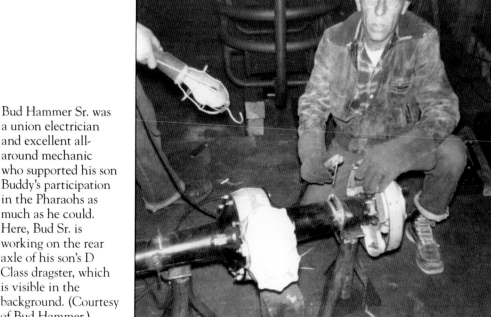

Bud Hammer Sr. was a union electrician and excellent all-around mechanic who supported his son Buddy's participation in the Pharaohs as much as he could. Here, Bud Sr. is working on the rear axle of his son's D Class dragster, which is visible in the background. (Courtesy of Bud Hammer.)

Oxnard resident Don Bottenhorn, a retired US Navy commander and Raytheon employee, was also a hot rod enthusiast and supporter of the local scene. He is seen here posing with an early fiberglass T-bucket body by Cal-Glass that Buddy Hammer of the Pharaohs will later build into a dragster. (Courtesy of Bud Hammer.)

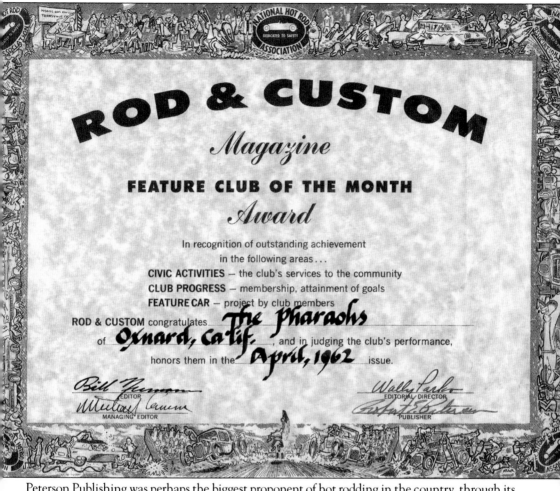

ROD & CUSTOM

Magazine

FEATURE CLUB OF THE MONTH

Award

In recognition of outstanding achievement
in the following areas...

CIVIC ACTIVITIES — the club's services to the community
CLUB PROGRESS — membership, attainment of goals
FEATURE CAR — project by club members

ROD & CUSTOM congratulates *The Pharaohs*

of *Oxnard, Calif.*, and in judging the club's performance,

honors them in the *April, 1962* issue.

Bill Neumann
EDITOR

Wally Parks
EDITORIAL DIRECTOR

MANAGING EDITOR

PUBLISHER

Peterson Publishing was perhaps the biggest proponent of hot rodding in the country, through its magazines *Hot Rod* and *Rod and Custom*. The company also fostered the "good guy" philosophy. Like the Motor Monarchs before them, the Pharaohs were featured several times in various magazines. The Pharaohs received this "Club of the Month" award in 1962. (Courtesy of Bud Hammer.)

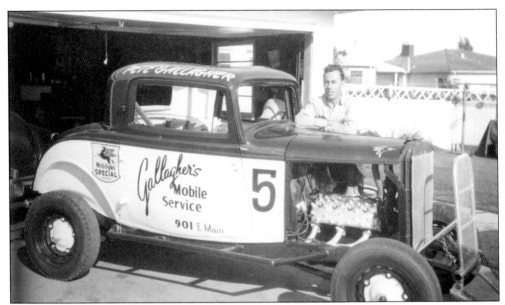

Gas station owner Pete Gallagher, although not known as a drag racer, was very prominent in the sport of dirt track racing, or "jalopy racing," as it was called back then. He raced several Ford Model As. The one shown below met its end at the Thunderbowl dirt track in Carpenteria, California, just north of Ventura. Gallagher owned stations under the Mobil and Tidewater brands for over 30 years in Ventura, was active in the local Rotary Club, and was a pioneer off-road racer as well, working on the innovative Baja Boot all-wheel-drive off-road racecar in the early 1970s.

This last image shows Jim Bohlen's 1934 Ford parked on old Highway 1 just north of Emma Wood State Beach, with Pitas Point visible in the background. Hot rods are still a part of Ventura County's cultural heritage, with new versions of clubs like the Pharaohs and the Coachmen making appearances at local car shows. There are several well-attended car shows each season in Ventura, with countless more throughout the rest of the county, the state, and the country at large. The National Hot Rod Association has an excellent website offering more information on the history of drag racing, and there are countless parts and accessories companies catering to hot rod enthusiasts. Hot rod culture is still going strong, and it looks like it will continue for some time to come.

GLOSSARY

Blower: Also called a supercharger; a compressor that pulls more air into an engine to increase power.

Bobtail: A dragster or hot rod with the driver's seat located over the rear axle of the car.

Bore: The diameter of an engine cylinder. If an engine has been bored, that means the size of the cylinder has been enlarged, increasing the engine's volume and thus its power.

Carburetor: The device that supplies an engine with an explosive mixture of air and vaporized fuel. The most popular carburetor with hot rodders was made by Stromberg.

Channeled: The lowering of a car's body over its frame, covering the frame rails. This is most common in pre-1940 cars.

Chopped: The removal of sections of a car from the pillars that are then welded back on in order to lower the body's profile. This is described in inches removed from the pillars, as in "a two-inch chop."

Coupe: A closed-top car, with two doors, usually seating two.

Custom: A postwar sedan or coupe that has had the body styling altered to suit the owner.

Decked: Removal of the chrome trim from a car's trunk lid.

Deuce: A 1932 Ford Model B. This can refer to either a coupe or a roadster.

Dragster: A car built especially for drag racing.

Flathead: A V-8 engine produced by the Ford Motor Company from the late 1930s until the mid-1950s and by far the most popular engine used in hot rods. It also refers to any engine with the valves located in the engine block, level with the pistons and not in the cylinder heads.

Fordor: A pre-1940 Ford four-door sedan.

Four-banger: A four-cylinder automobile engine.

Frenched: When items such as the headlights or turn signals have been "sunk" below the bodywork. This is seen on custom cars.

Fuel-injection system: A system that supplies the air/fuel mixture into an engine by injecting a controlled, measured amount into each cylinder. It is considered superior to carburetion.

Fueler: A dragster with an engine modified to run on special fuel blends for more power.

Funny car: A drag racer with a stock-appearing body, but drastically modified for racing.

Gasser: A dragster with an engine that runs on gasoline.

GM: The General Motors Corporation.

Highboy: A pre-1940 car that has had its fenders removed. This is most commonly done to 1929–1932 Ford roadsters.

Hemi: An innovative V-8 engine introduced by the Chrysler Corporation in the early 1950s, so called because it had hemispheric combustion chambers for more power.

Kit car: A car assembled from a kit, usually with a fiberglass body and on a standard production car frame.

Model A: A passenger car produced by the Ford Motor Company from 1928 to 1931.

Model B: A passenger car produced by the Ford Motor Company in 1932.

Model T: A passenger car produced by the Ford Motor Company from 1909 to 1927.

Mopar: Any product produced by the Chrysler Corporation.

Nerf bar: A rudimentary front or rear bumper fashioned from chromed-steel bar stock.

Nosed: The removal of the chrome trim from a car's hood.

Overhead: An engine with the intake and exhaust valves located in the cylinder head instead of in the block, giving it more power. Many aftermarket kits were available to convert flathead engines to overheads.

Phaeton: An open-top, four-door touring car built prior to 1940.

Rail: A dragster that has been stripped down to its frame rails to lighten it for competition.

Roadster: An open-top, two-seat car.

Roll bar: A structure made from heavy metal pipe that is placed behind the driver for protection in case the car rolls over.

Sectioned: The splitting of a car's body into sections, which are then welded back together in order to change the body's profile.

Sedan: A closed-top car, usually with four doors and seats.

Shaved: The removal of items such as door handles and side trim from the sides of a car.

Shoebox: A 1949–1951 Ford coupe, so named because of the car's boxlike shape.

Slicks: Tires specially made for drag racing that are wide, have no tread, and are made of soft rubber for better traction.

Slingshot: A dragster built so the driver sits behind the rear axle

Stock: A car that is equipped as it came from the factory, with no modifications.

Straight-six: An engine with six cylinders arranged in a straight line.

Stroke: The distance the piston travels in an engine's cylinder. When the distance is increased, it is called "stroking." An engine that is bored and stroked has been modified to increase the power.

T-bucket: A hot rod with a 1909–1927 Ford Model T roadster body.

Tudor: A pre-1940 Ford two-door sedan.

V-8: An engine with two rows of four cylinders diagonally opposed and connected to a common crankshaft.

Wheelie: A wheel-stand performed by a dragster when the sudden acceleration at the start of a race lifts the front wheels off the ground.